Rock Stars of the '80s and '90s

A Collector's Book of Memorabilia

Victoria E. Mitchell

Eloquent Books
New York, New York

Eloquent Books
An imprint of AEG Publishing Group
845 Third Avenue, 6th Floor — #6016
New York, NY 10022
www.eloquentbooks.com

ISBN: 978-1-60693-603-0
SKU: 1-60693-603-4

Printed in the United States of America

I dedicate this book to God first, who gave me my talents and allowed me to bring them out to the world; to Jon Butcher and Stevie Ray Vaughan, for giving me my start in professional music photography; to Providence, R.I., where I lived and worked from 1987 to 1994; and to 94 WHJY in Providence for all the great memories! Thank you!

I'd like to offer a special dedication to the victims of The Station nightclub fire of February 20, 2003. A hundred people were killed and over 200 were injured when the pyrotechnics display at the start of a Great White concert at The Station, located in Warwick, R.I. ignited a devastating fire onstage. I am donating a portion of all my proceeds from this book to help the victims and their families. Donations can be made online at www.StationFamilyFund.org. God bless you all!

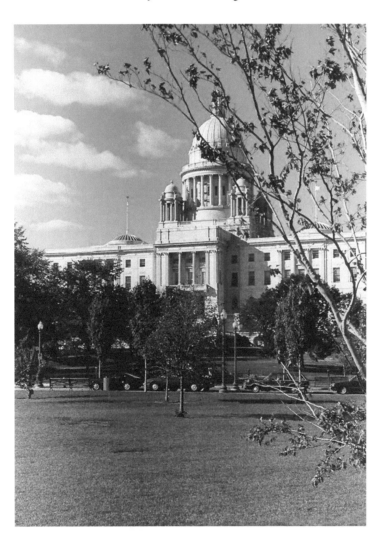

The Providence State House, spring of 1990

Special thanks goes to Jim Corwin and Tim Gaulin from 94 WHJY in Providence, R.I., Marc J. Golden of Salem, Mass., and Scott Barb, drummer for the Moody Hooters of Ness City, Kansas, for their help in compiling information for this book; also to my family, to George Lockett of www.healergeorge.com, Jon Butcher, CC of *www.ccthehuntress.com*, Glenn Stewart of New Bedford, Mass., Mark Normand of Lawrence, Mass., and to all my friends on the Jon Butcher Yahoo e-group. They all gave incredible friendship and support. Thanks to Dutch Vannorren of Vero Beach, Fla., for all his help, to Scott Barb and Willi Miller of Vero Beach, Fla., for editing, and to my daughter *Ariel* for creative input. Photo conversions done by *AutumnThyme Designs* in Vero Beach, Fla. You all helped make this book possible!

Contents

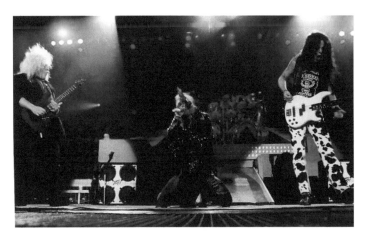

Back Cover Collage: Photo of Victoria and Her Children (Ariel, 12; Jeremy, 4; and Autumn, 22 months) on Wabasso Beach, Florida, April 2008, along with Ted Nugent, Jon Butcher, Bret Michaels (from Poison), Stevie Ray Vaughan and Friends, Rik Emmett, Winger, Jon Butcher's Guitars and Tour Bus, Timothy B. Schmidt (from the Eagles) with Jon Butcher Axis, Albert Collins, King's X, plus Backstage Passes

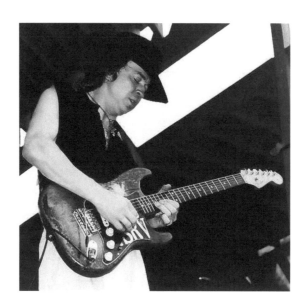

In 1987, when I was twenty-one years old, I did something that changed my life. I followed my heart and began on my course to becoming a professional photographer. Photography had been a passion of mine for some time already, started by my grandfather, Henry Haladay. When I was young, he used to show me all the pictures he had taken in the 'old days', usually with his brother, Fred, my grandmother Mary Catherine and their friends. I loved the way a certain feeling could be captured in a photograph for all eternity. With just one glance at it, a photograph can speak a thousand words. With this understanding, my main objective became putting my heart and soul into whoever I am photographing, which rewards me with the same feeling back from my subjects. This creates a lasting, inspiring impression to be seen forever, captured in one moment of a soul's full expression. I have always truly enjoyed music and it's such a passionate profession, that it made it seem almost effortless for me to capture the essence of the musicians. I really admire the talent and dedication it takes to become a great musician. Add to that talent and dedication the ability to fully and freely express yourself and all of those talents, and a star is born! This book is full of talented and driven people, who used all they had available to them to become who they are.

By 1989, before I had even finished my photography course, I knew what I wanted to do. I decided that I wanted to photograph someone I respected and admired in the music world, Jon Butcher, who

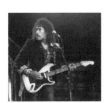 allowed me to photograph him. I had seen Jon Butcher Axis play so many times already, I'd lost count. I couldn't wait to capture all the electricity, fun and raw talent Jon always projects out into every audience he's ever played for. The photos I took of him came out phenomenal, and this is where my professional music photography career was born. I'm grateful to have the honor of having one of my photos of Jon Butcher on the cover of one of his CDs, *The Best of Jon Butcher… Dreamers Would Ride*. It was released in 1999. It has always been a great pleasure to see Jon play and I've enjoyed watching his musical career flourish in so many ways over the years. I'm glad he's still rockin'!

After photographing Jon I decided that I wanted to photograph someone else that I really admired, Stevie Ray Vaughan. I did some research and I found Stevie's publicist, Charles Comer and called and told him what I wanted to do. We had some very good conversations and he also decided that he wanted to help me get where I wanted to go in this profession I'd chosen. With Charles' help, I was able to meet Stevie and take some of my favorite photos that I've ever taken. Sometimes I still can't believe that Stevie and all his talents, passion and kindness are gone. For so many, he will never be forgotten. May he rest in peace.

After photographing Jon a few more times, I made another decision. I wanted to take photographs for the newly formed radio station 94 WHJY in Providence, Rhode Island. Merv Griffin had just bought it and I knew that they would need someone to help elevate the station to where they wanted it

to be. So, armed with all of my photos and a lot of ambition, this is where I went. After looking over my portfolio, they hired me immediately. For the next three and a half years, day or night, I did all of their publicity, studio, trade, remote, in-house employee, backstage and concert photography. I

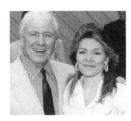

worked very hard and professionally. I also had a lot of fun! I met so many intelligent and talented people. I felt very blessed. I also had my own studio at that time called Victoria's Photography and photographed a lot of the local bands in the area, as well as weddings, portraits and on-location family photos and social functions. At the same time, I managed a local Rhode Island original band called Graphic Moves. They were popular in several of the local clubs and had a good following. We had a lot of fun! Before going out on my own, I had worked for some time with Bill and Ella Donnelly at GH Photography Studio in East Providence, Rhode Island. Then before moving to Florida in 1994, I worked at SBI Sales in Providence for two years when it was still on Bassett Street. In the year before I left Rhode Island, I balanced my work in the public eye by becoming a Samaritan, a suicide prevention counselor. I also learned professional photography representation in classes with Selena Oppenheim, a very well-known and respected representative for photographers in the Boston area. Although I live in Florida now, I will always consider Providence, Rhode Island to be where I call home. Providence was a backdrop for so much of my work and I loved living there. I applaud Mayor David Cicilline for completely revitalizing this beautiful and diverse city and I enjoy visiting it.

The photographs in this book are my favorites and very special to me. They bring back many great memories. I was able to take many photographs of some bands, some just a few, depending on the circumstances of the shoot. My collection of photographs, all taken between 1989 and 1992, is so huge that I had to pick the best shots and the most famous musicians of the time to represent the era and my life. Life had such a great feeling in this time period and that's what I want to bring back to you with the publication of this book. With the current comeback of music from the '80s and '90s, I thought it was the perfect time to offer this collection. Whether you were in the audience for any of these concerts or just love listening to these musicians decades later, this book is for you! I was blessed with the talent and the opportunities to do this work and it's my desire to share it with you.

I truly hope you enjoy this book for years to come and that it helps you relive your own great memories from a very special time in the history of music!

Blessings To All!

Victoria E. Mitchell

Commencer

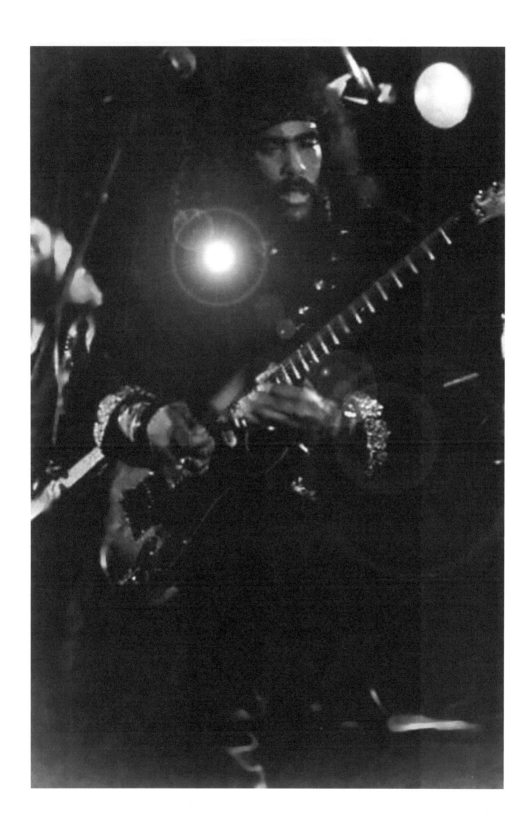

STEVIE RAY VAUGHAN
October 3, 1954–August 27, 1990

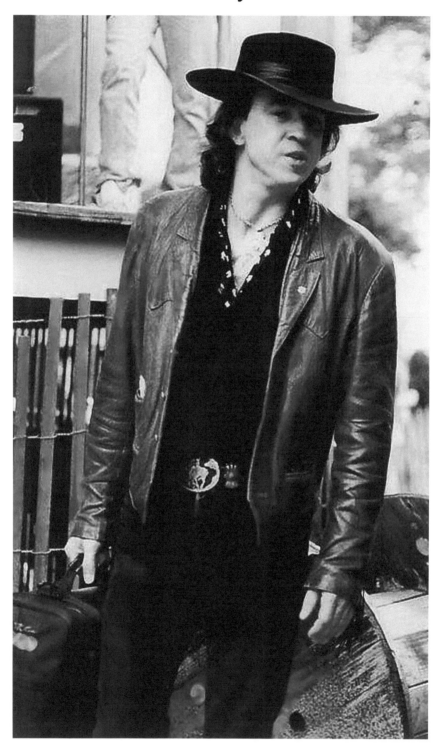

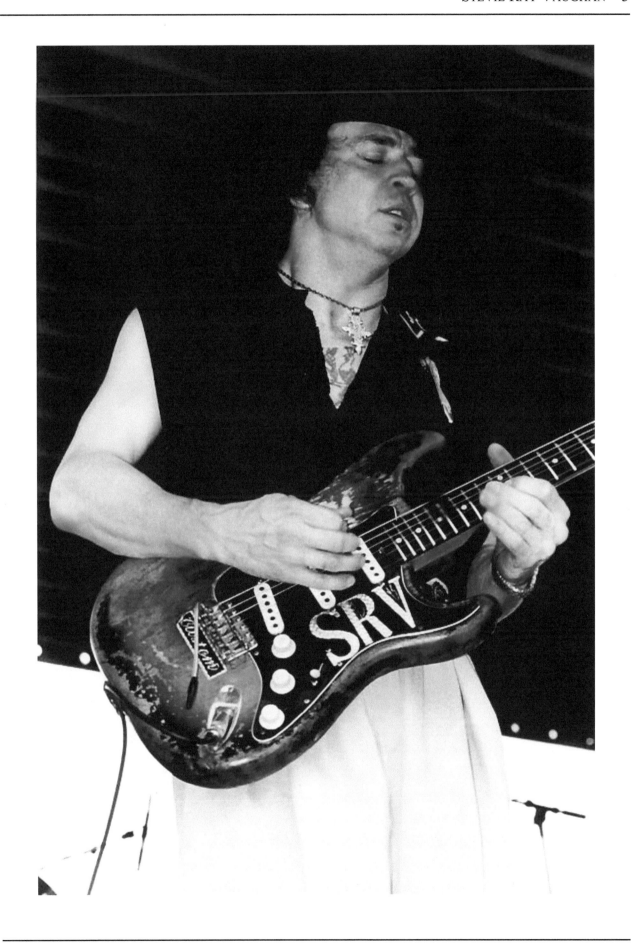

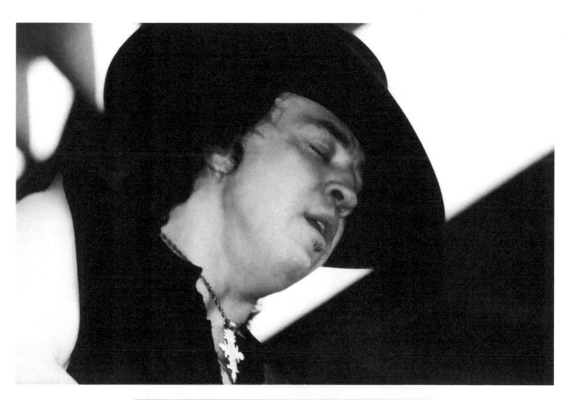

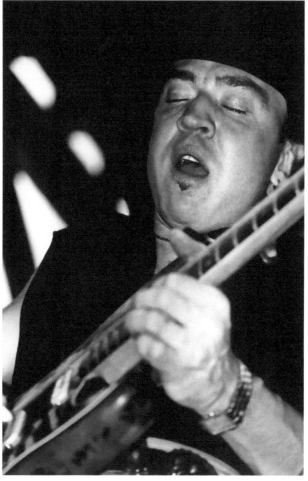

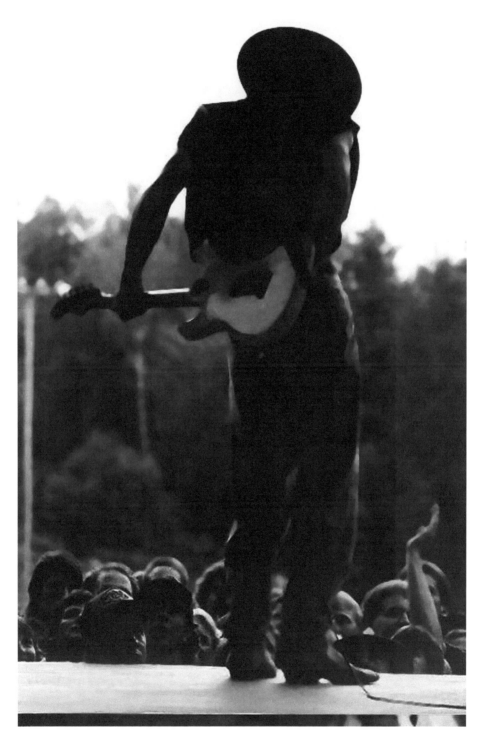

Timeless and Forever...

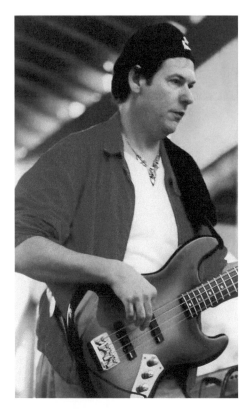
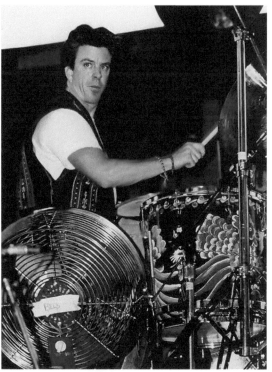
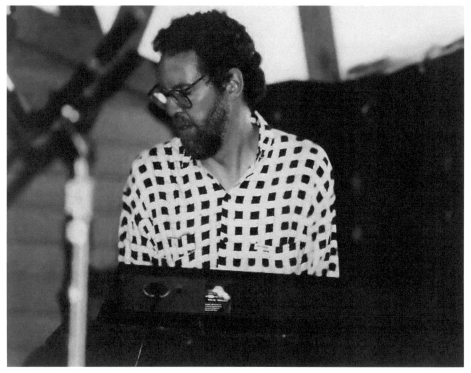

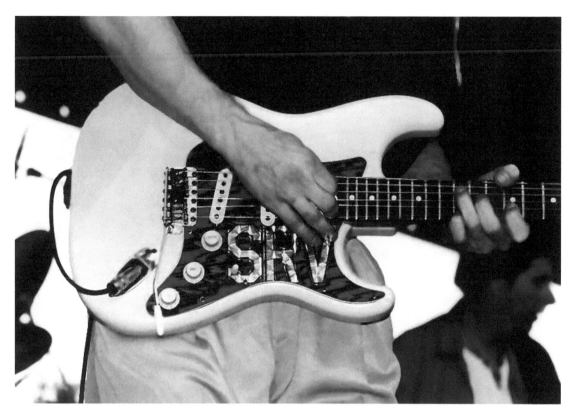

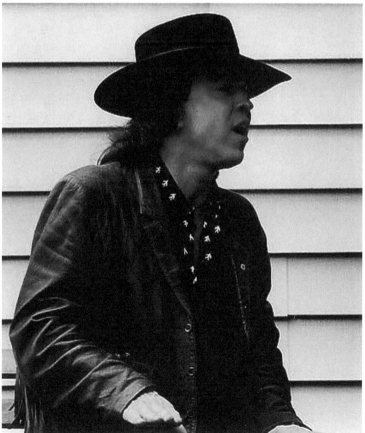

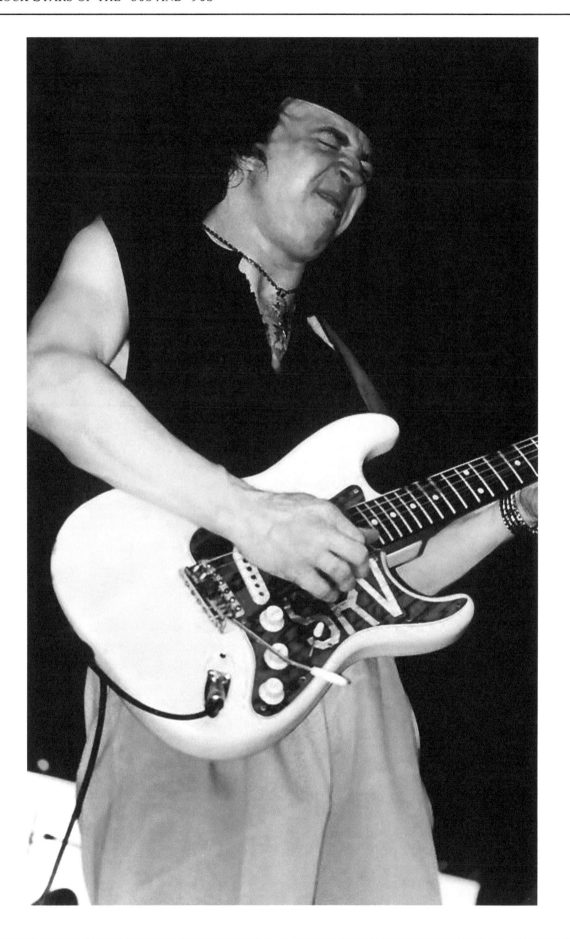

JOHN BUTCHER AXIS

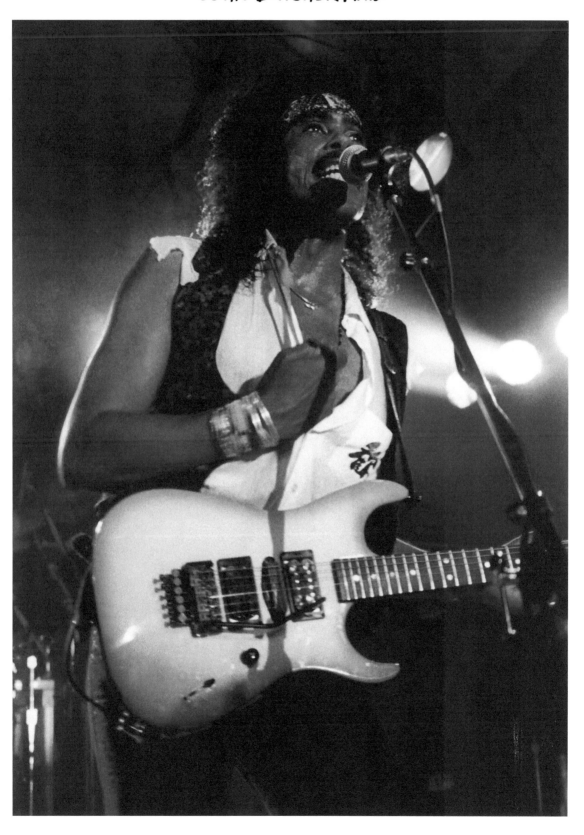

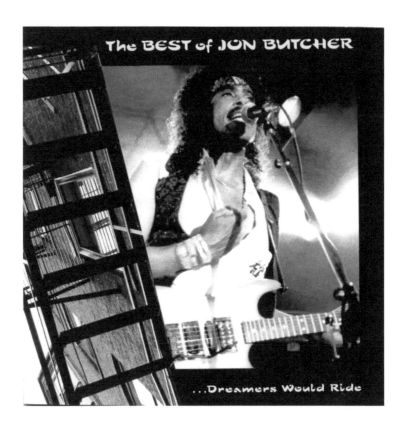

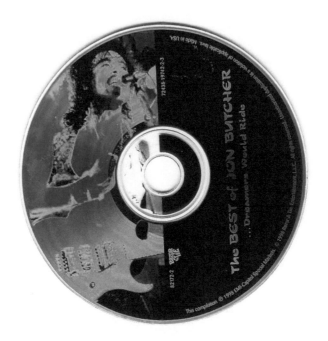

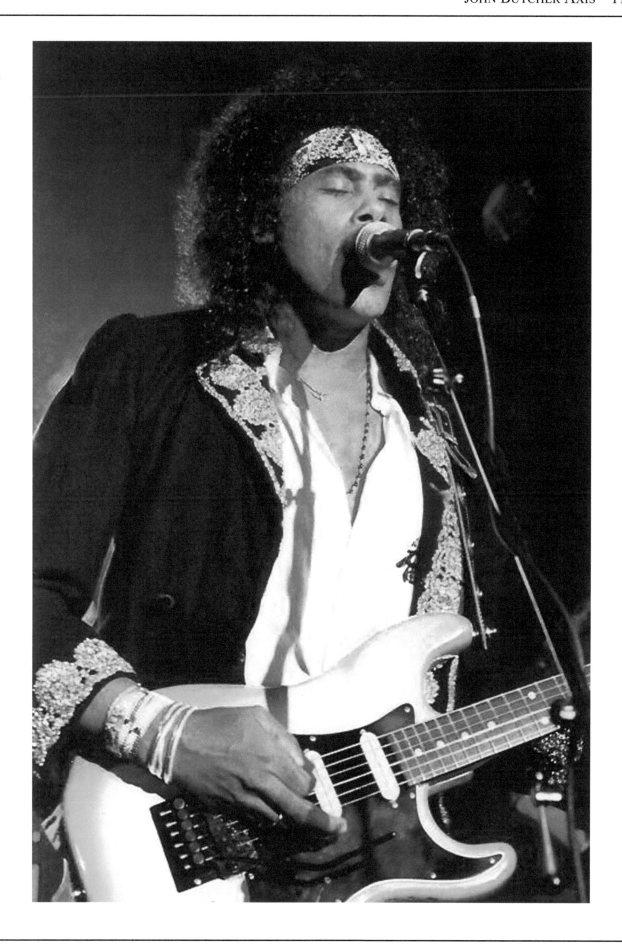

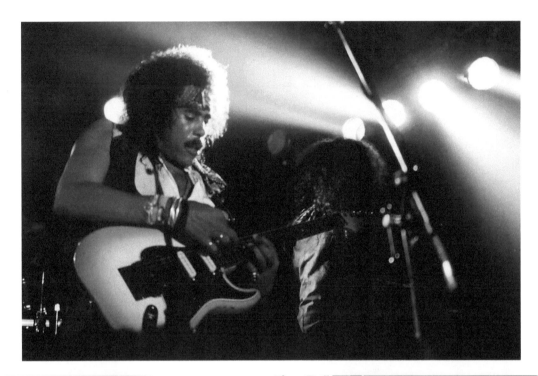

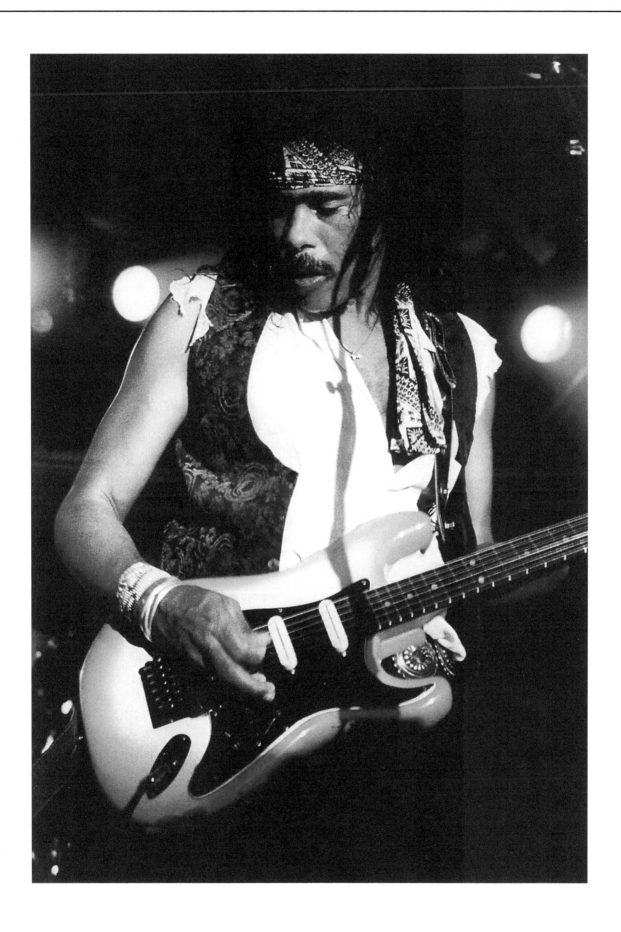

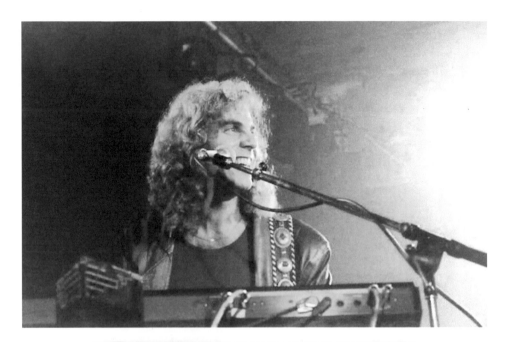

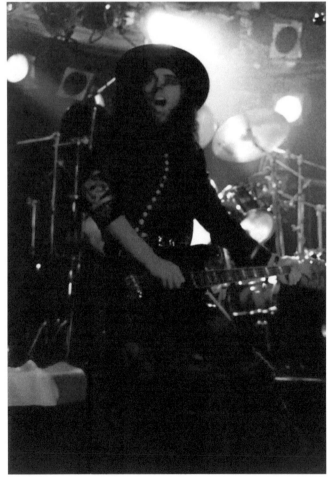

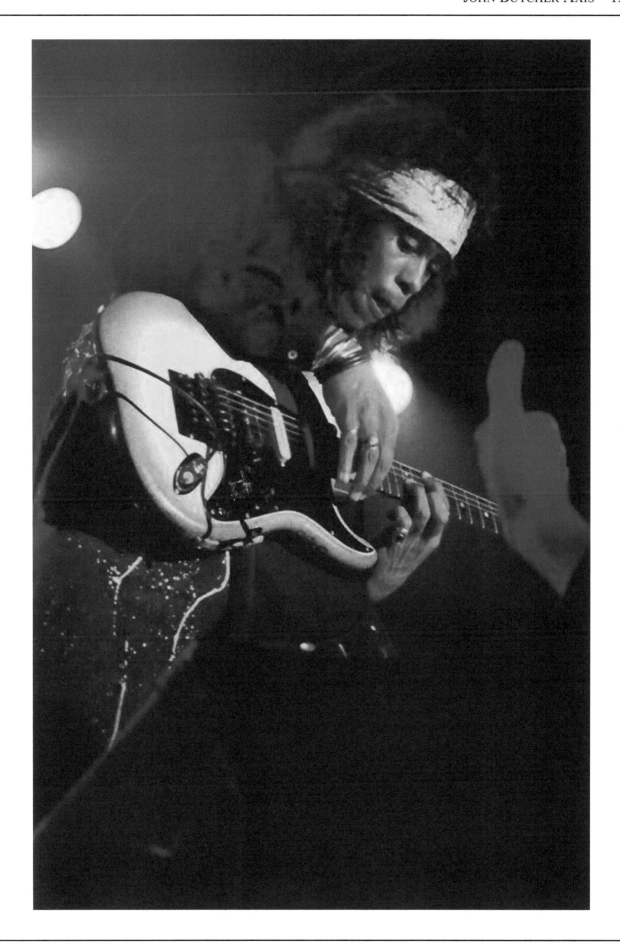

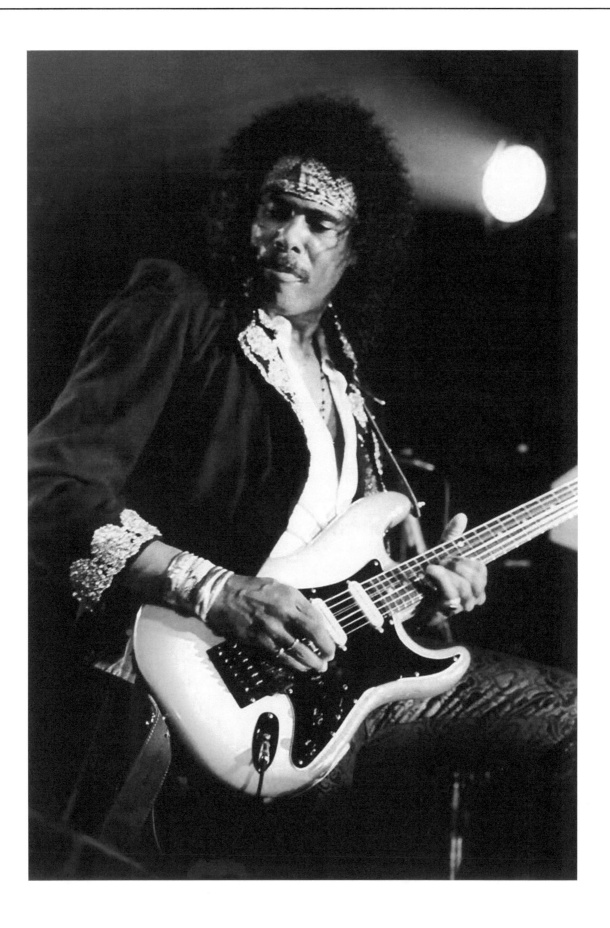

BLACK CROWES

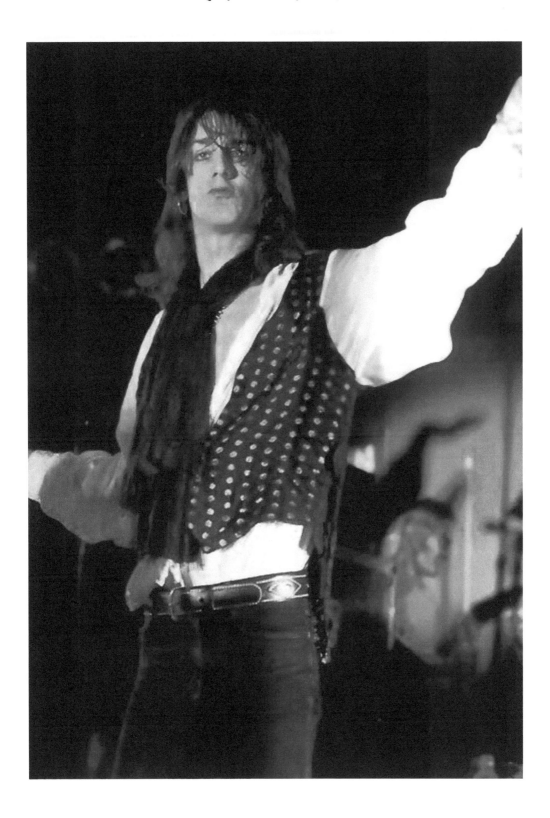

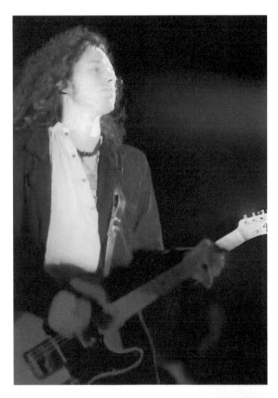

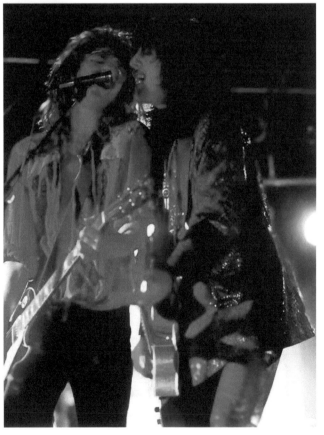

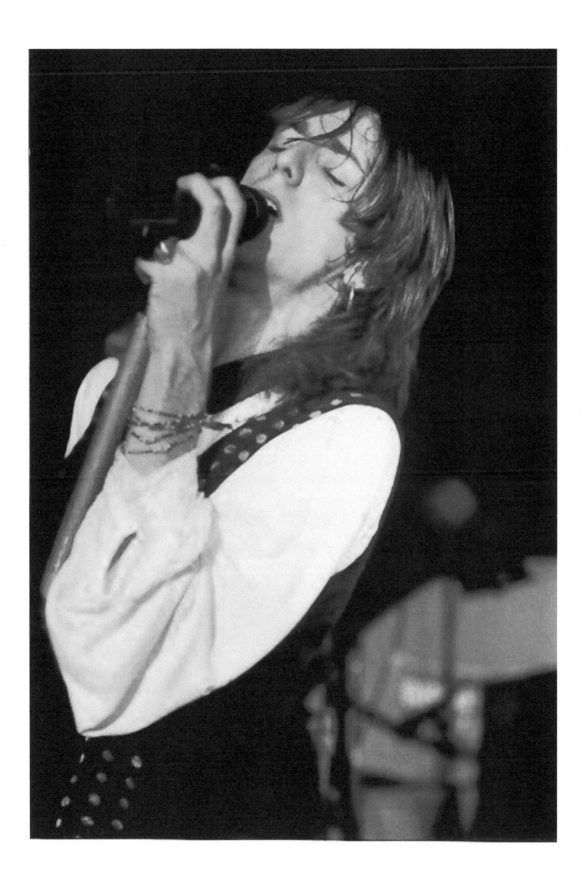

POISON

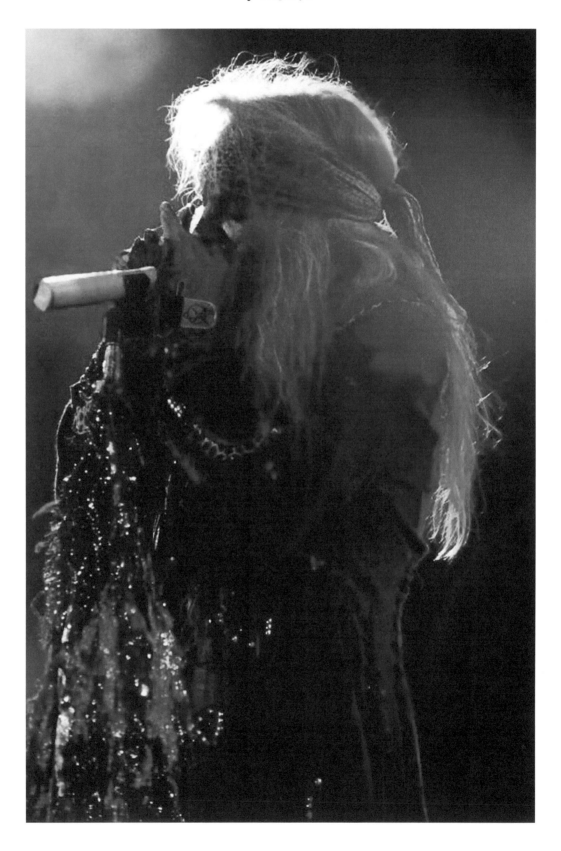

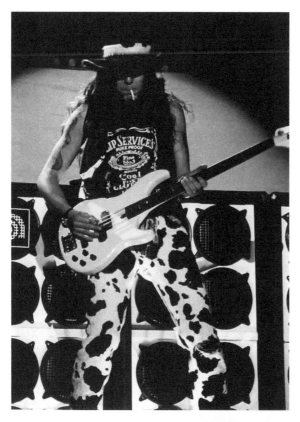

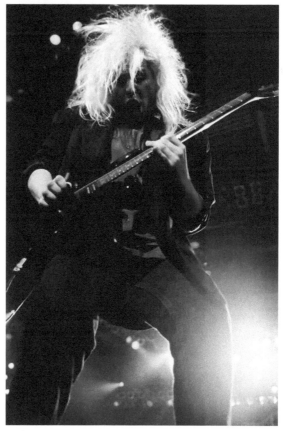

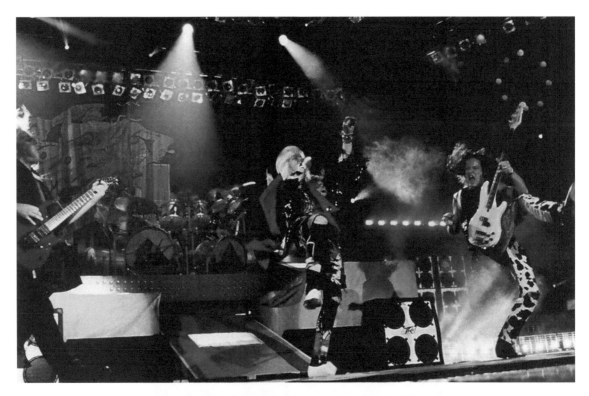

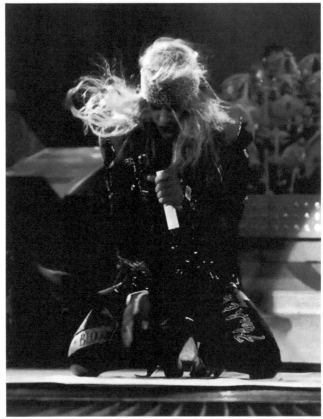

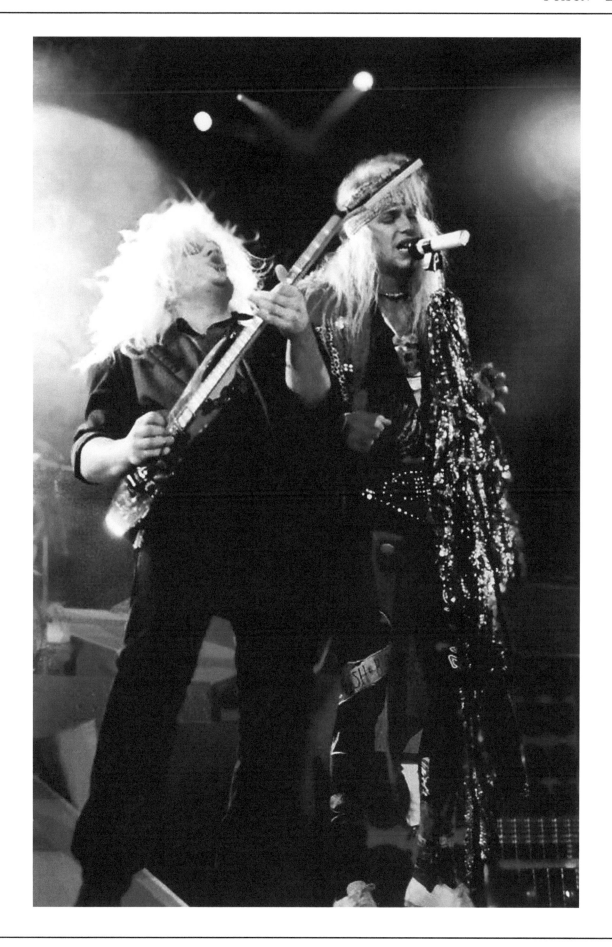

JETHRO TULL

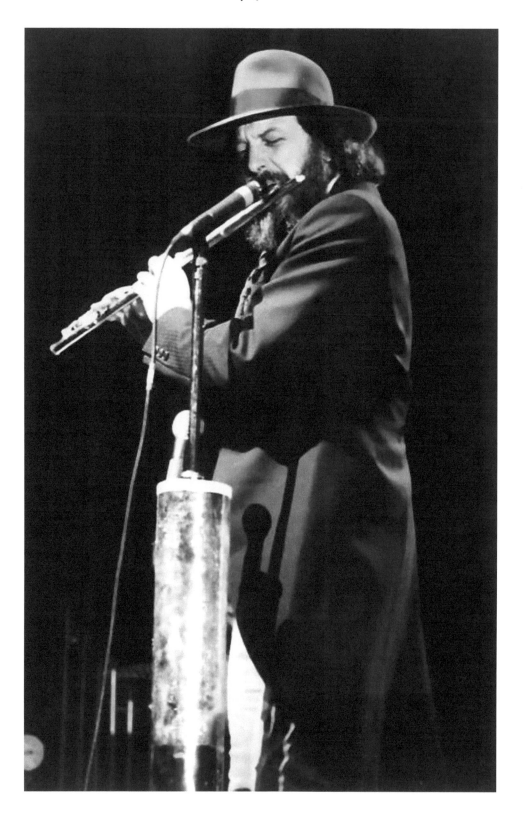

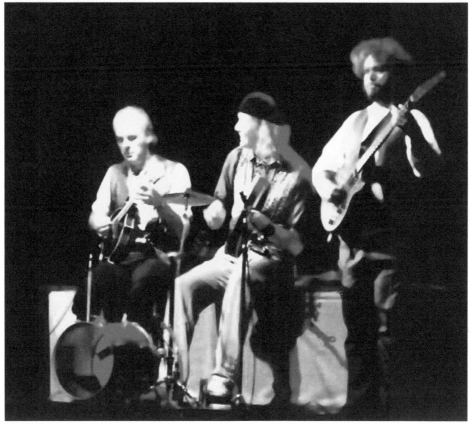

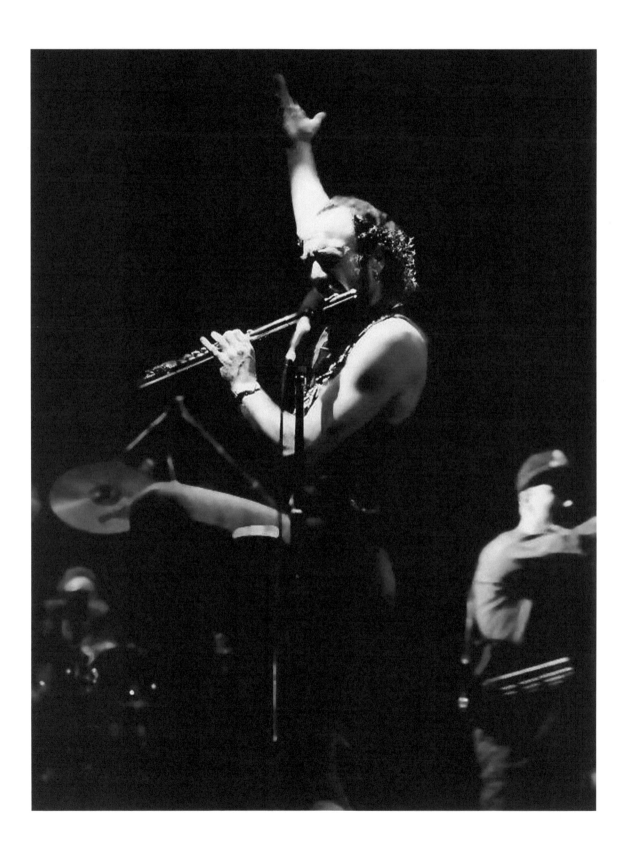

AEROSMITH

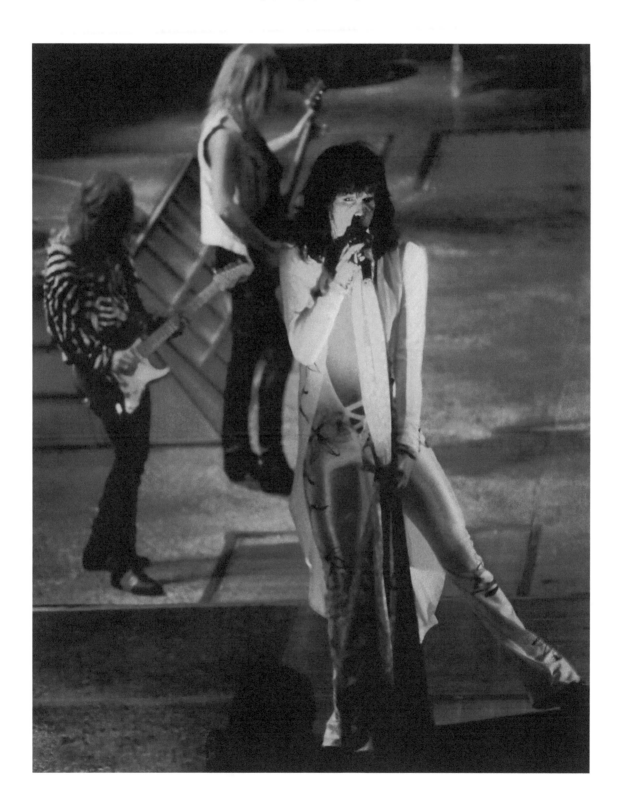

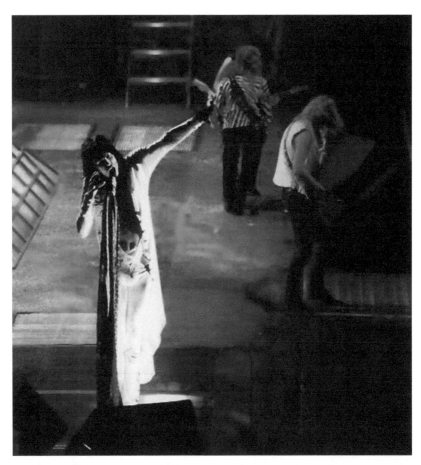

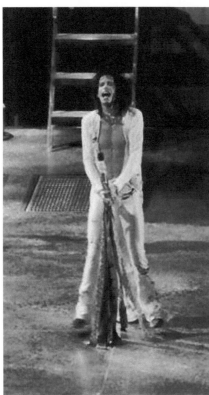

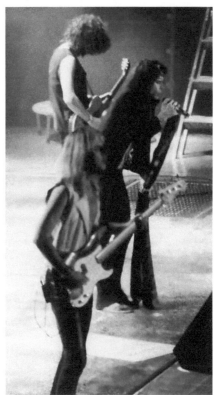

NOEL REDDING
from The Jimi Hendrix Experience
December 25, 1945—May 11, 2003

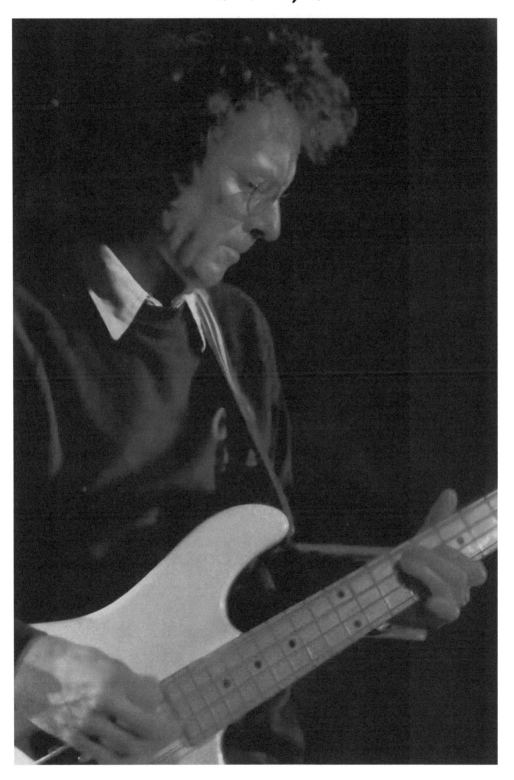

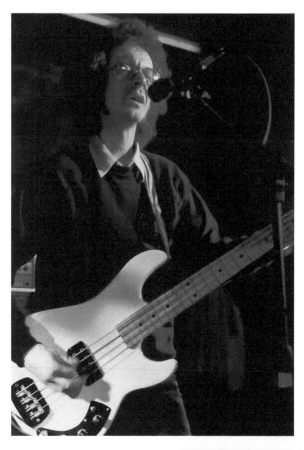

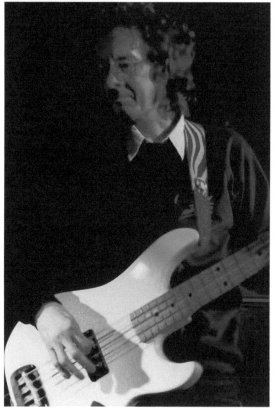

WHITESNAKE

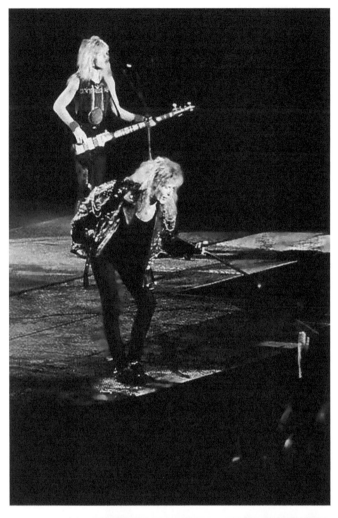

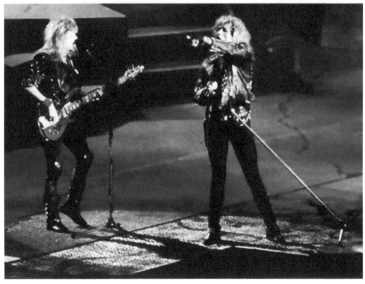

EXTREME

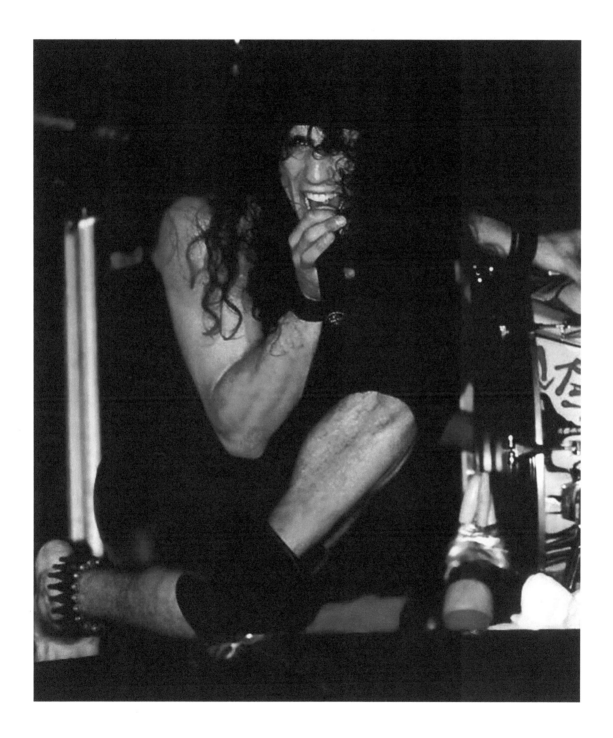

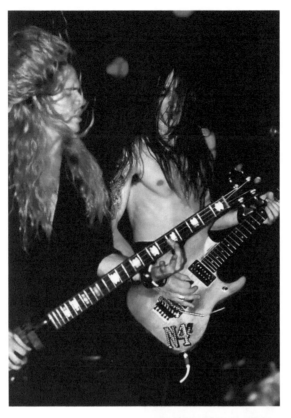

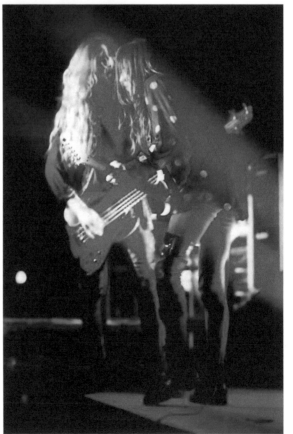

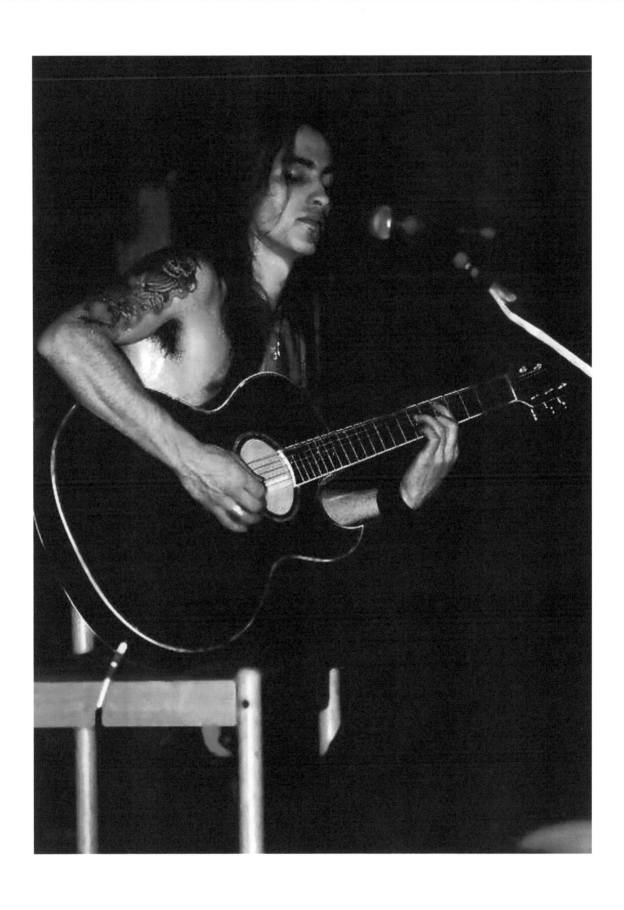

ZZ TOP

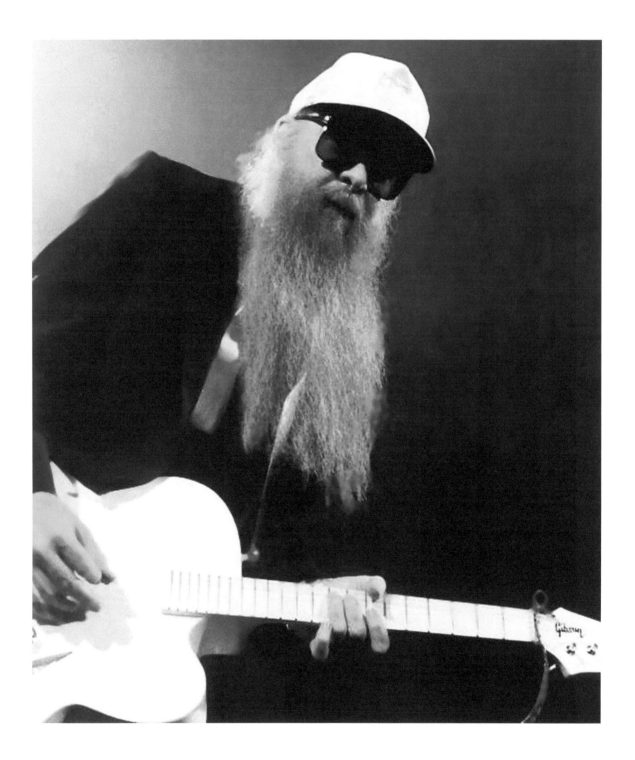

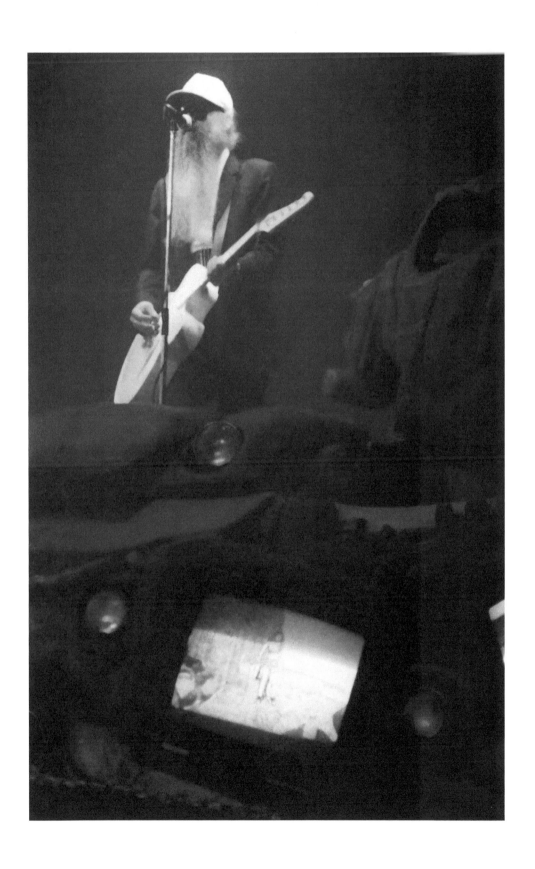

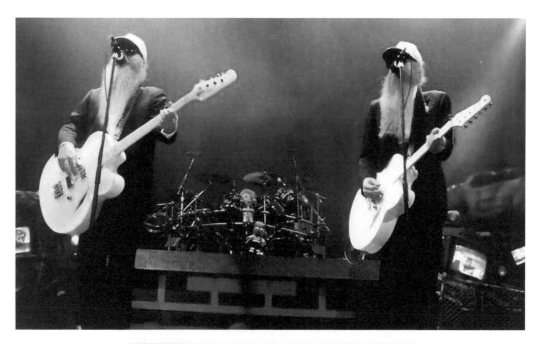

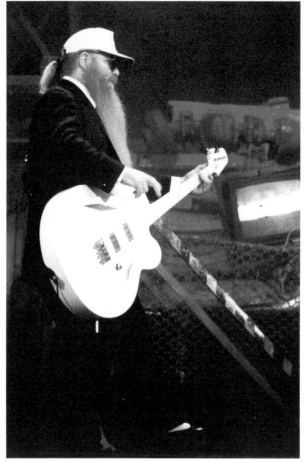

DAMN YANKEES

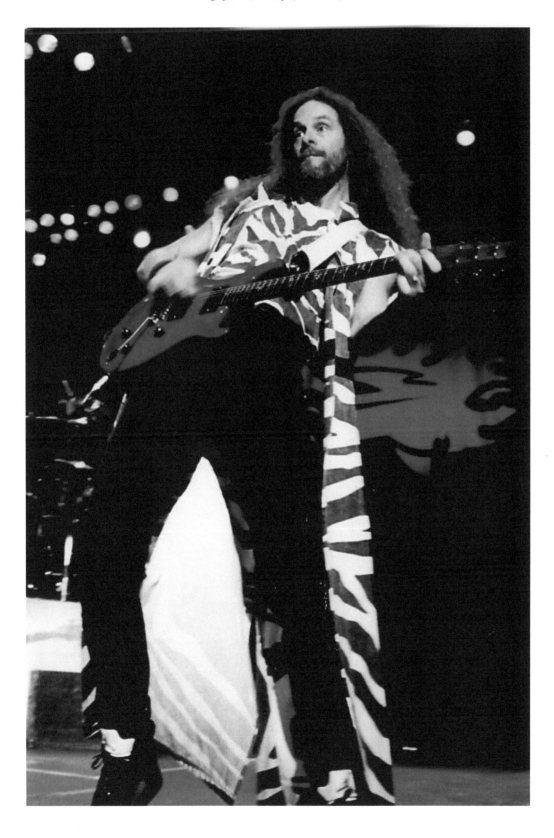

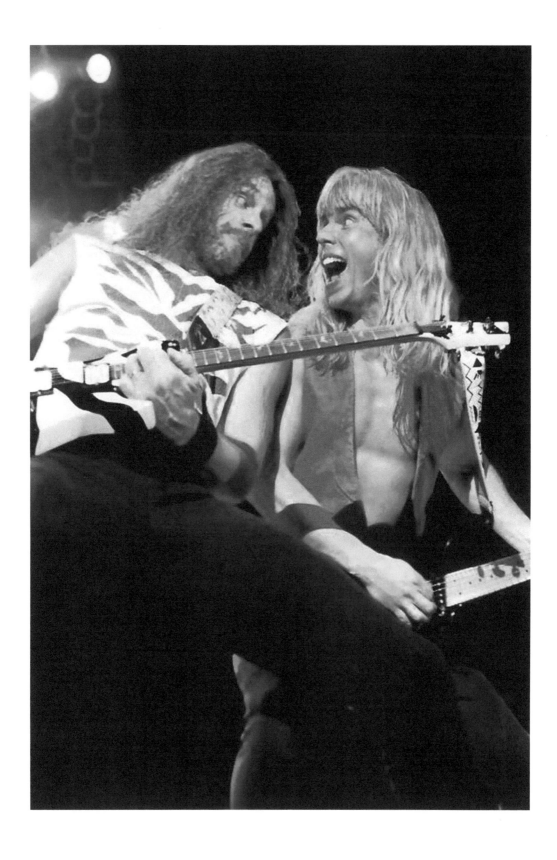

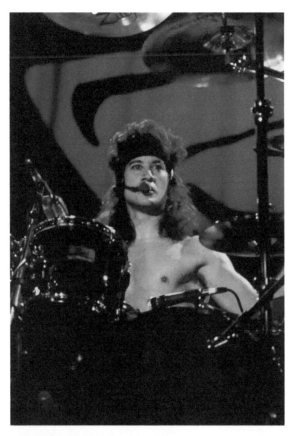

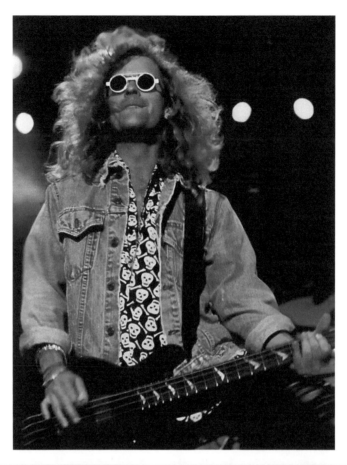

Kiss

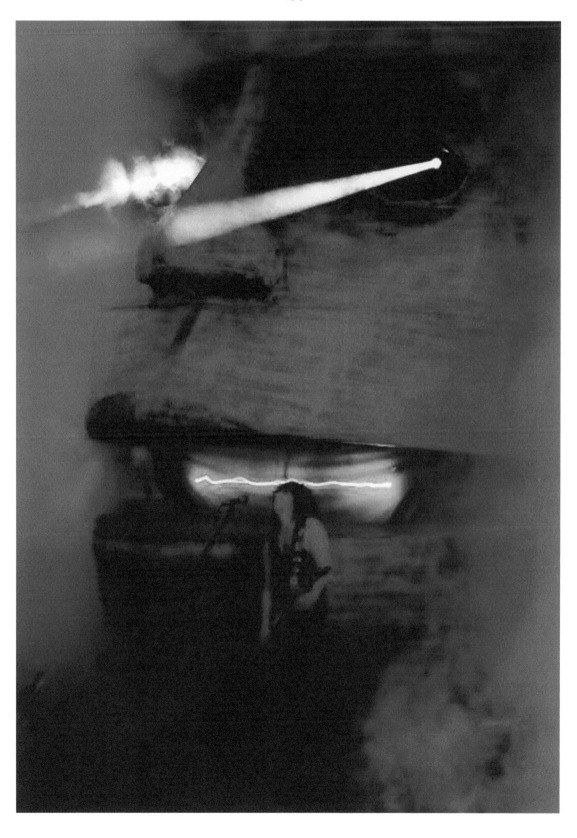

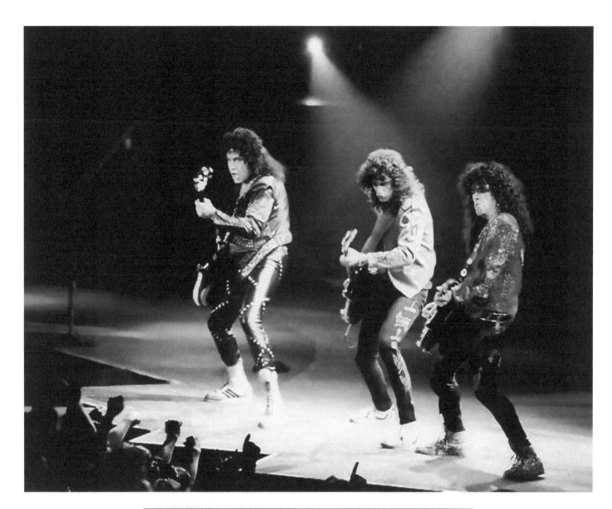

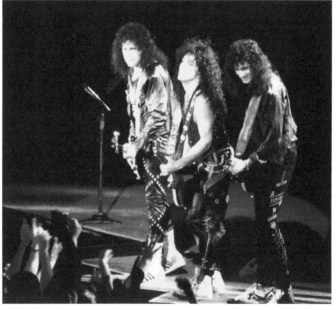

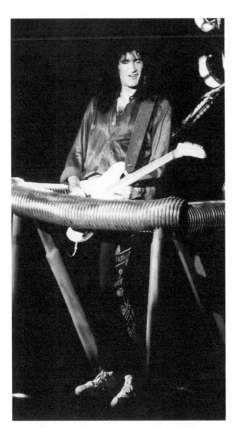
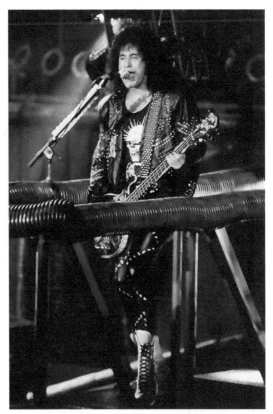
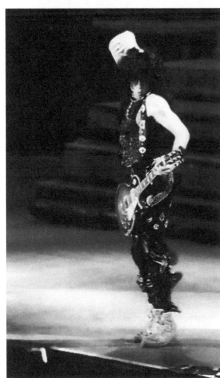
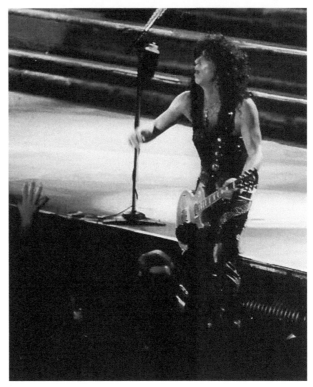

BILLY SQUIER

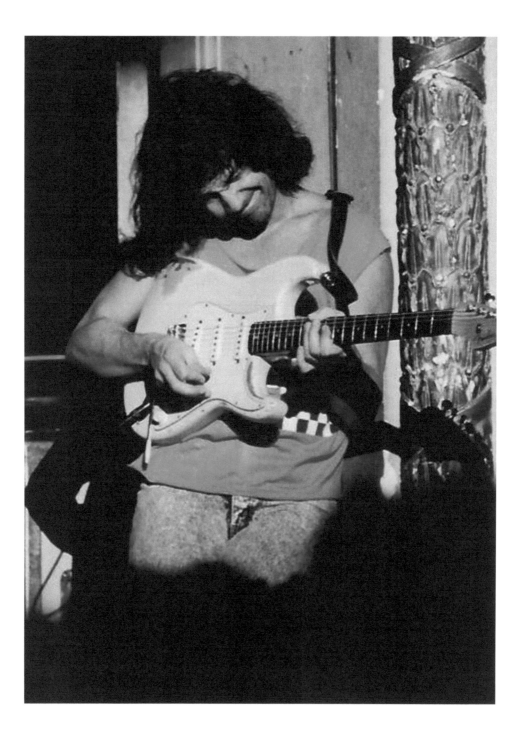

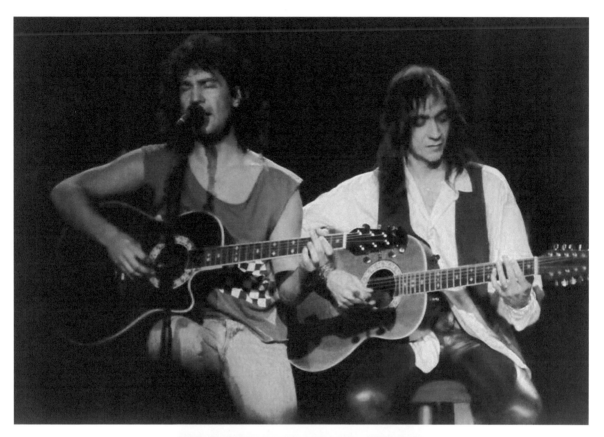

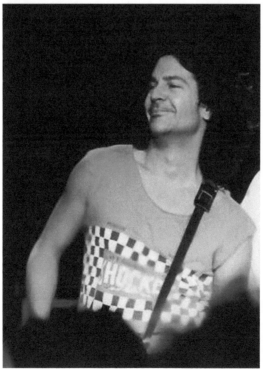

INDIGO GIRLS

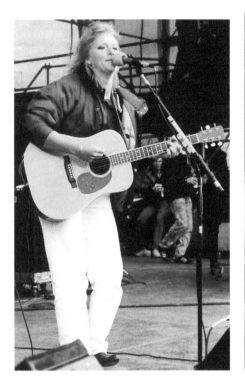
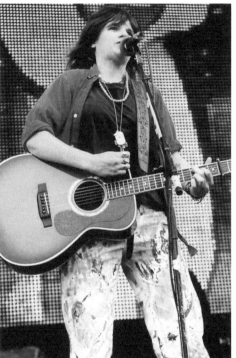
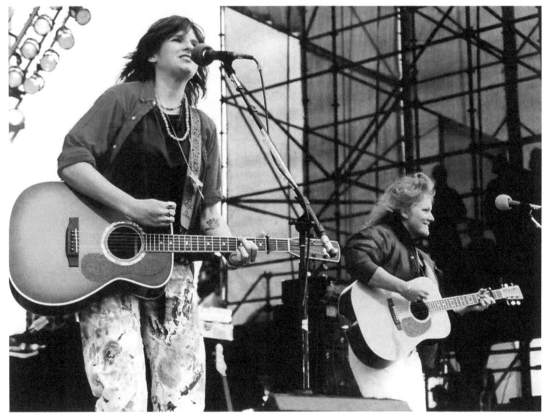

THE NELSONS

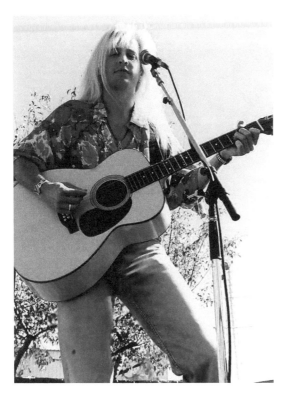

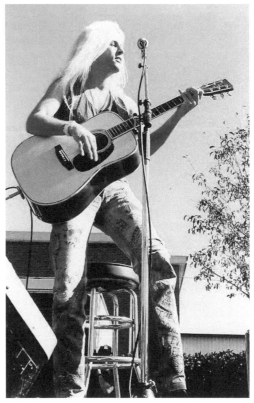

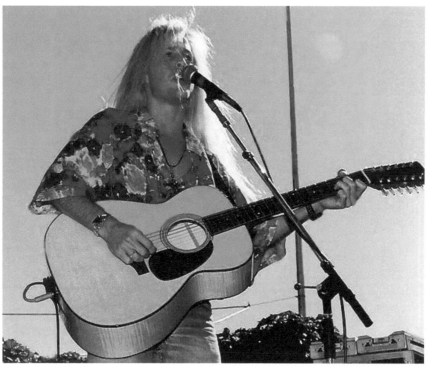

PETER WOLF

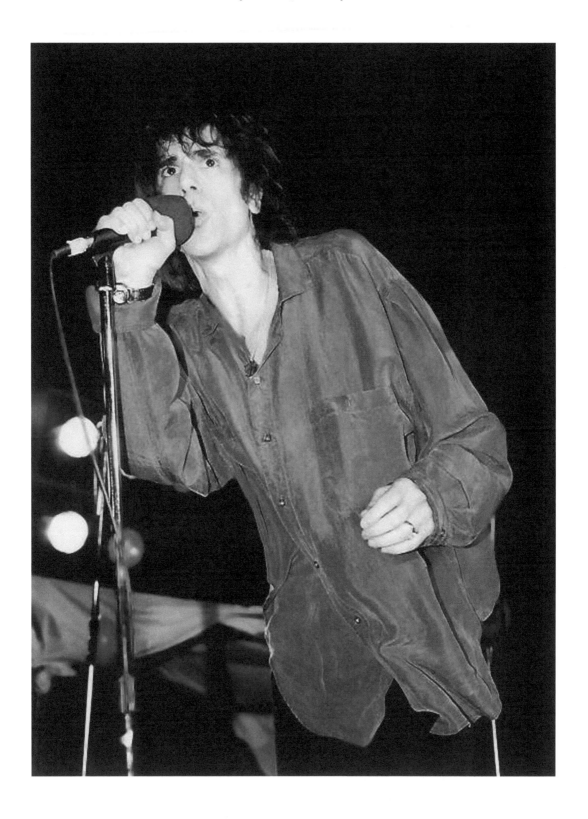

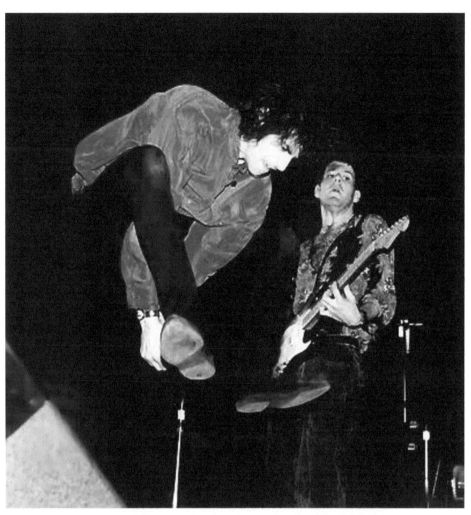

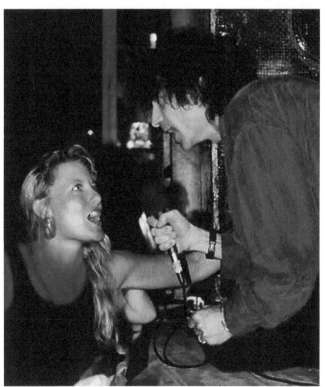

JOHN HIATT

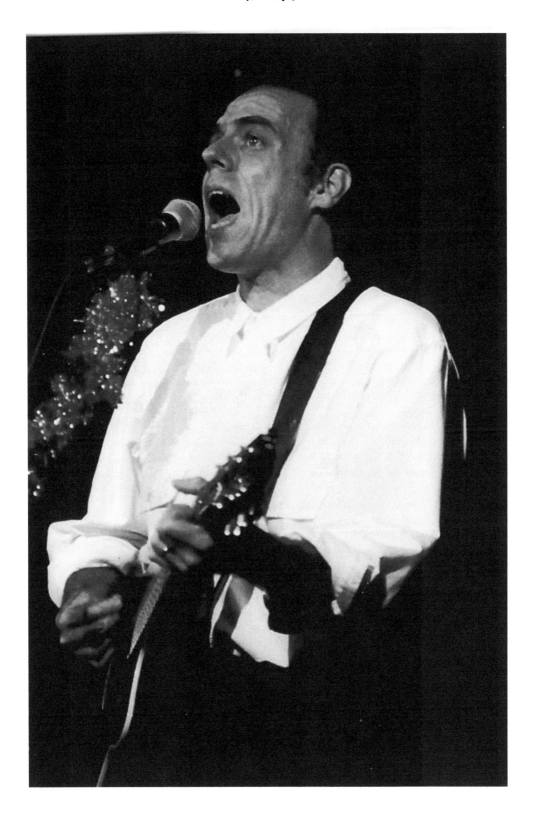

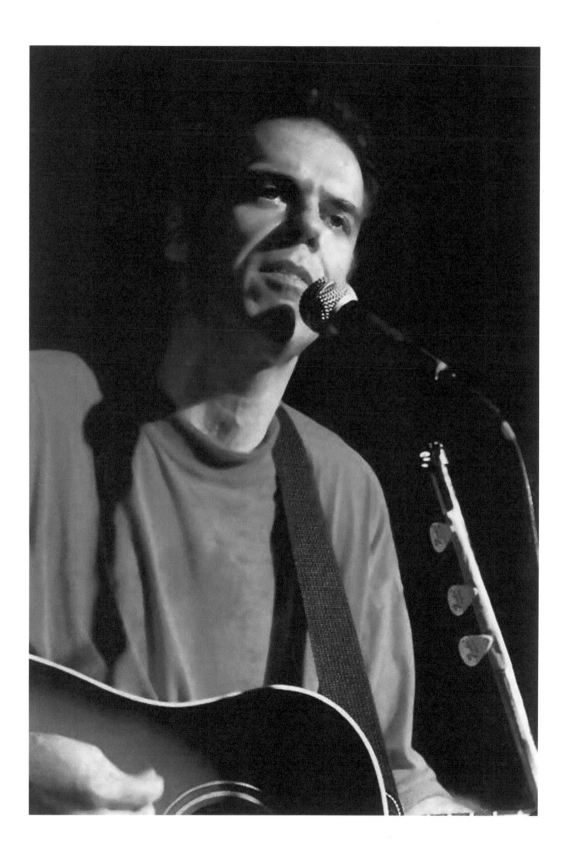

RIK EMMETT

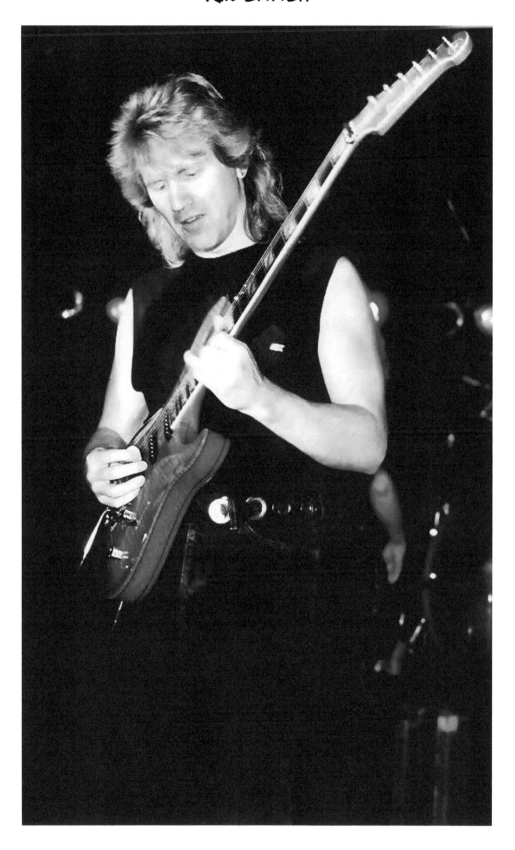

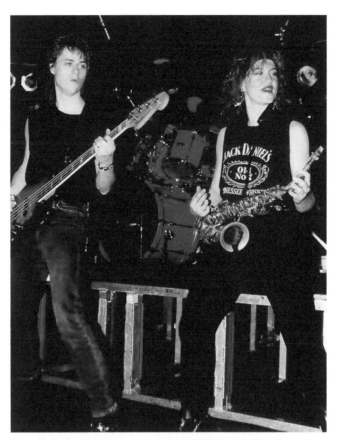

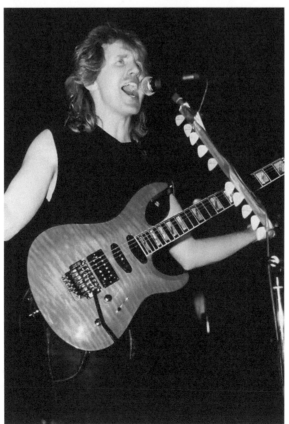

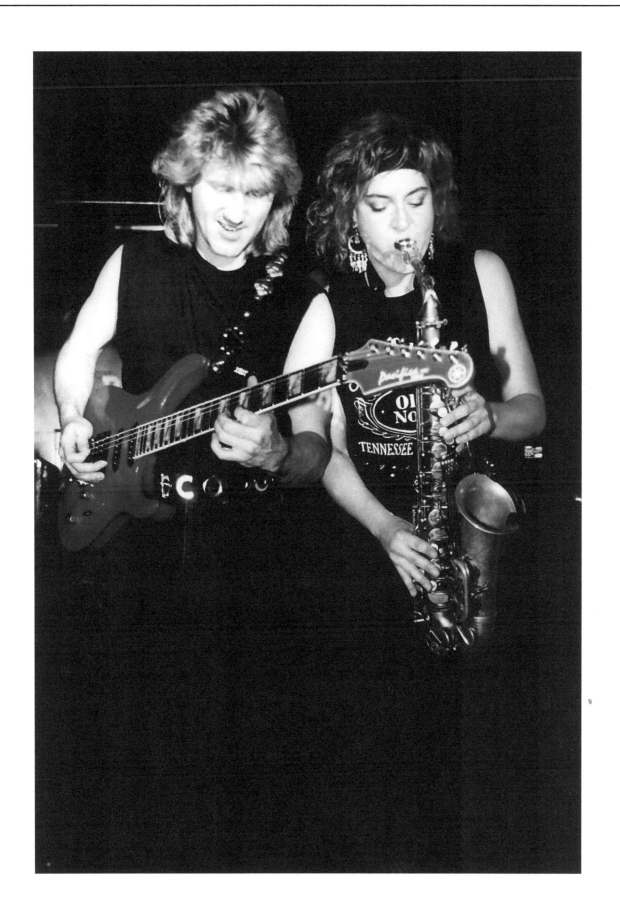

TRIXTER

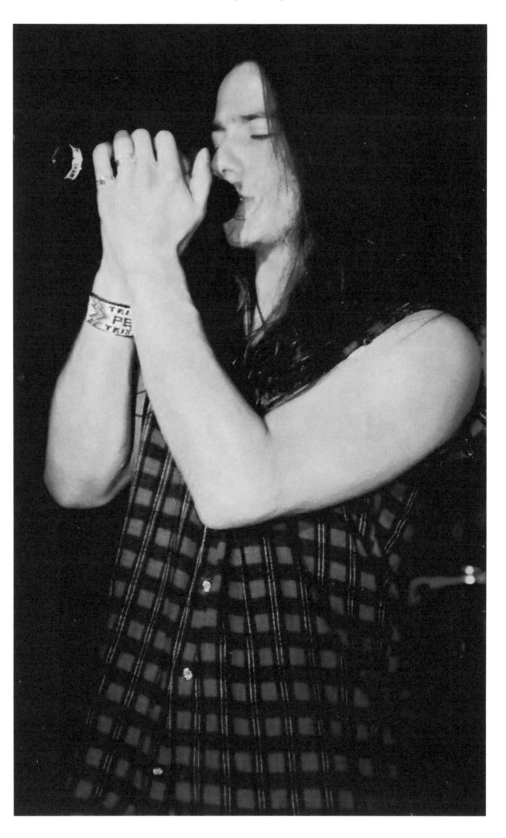

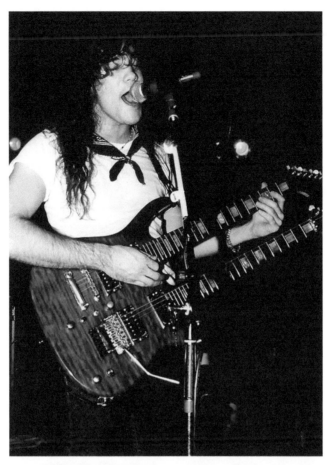

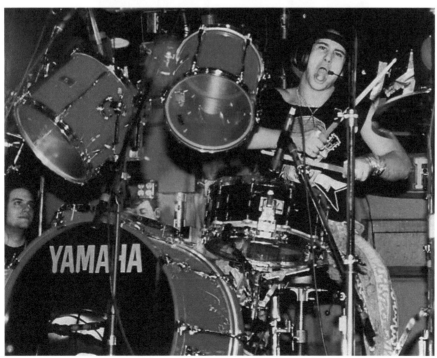

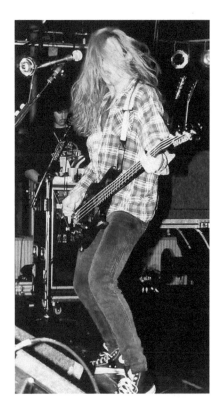

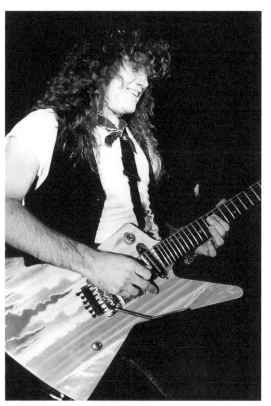

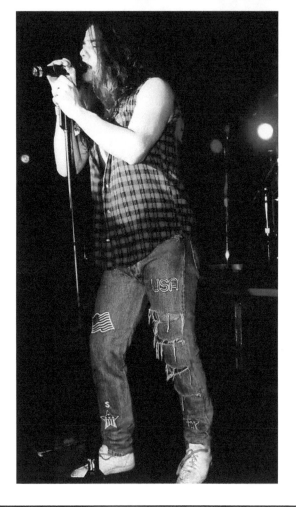

REMBRANDTS

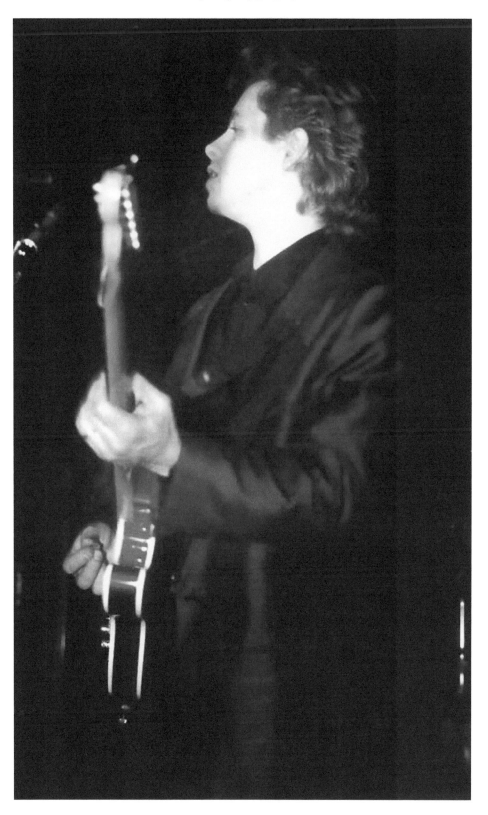

REMBRANDTS

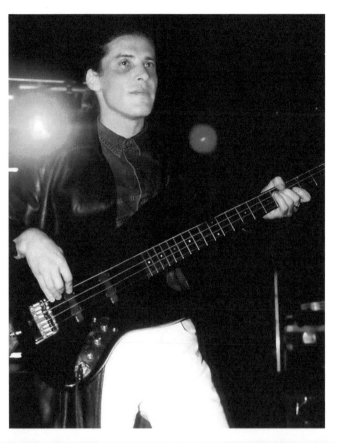

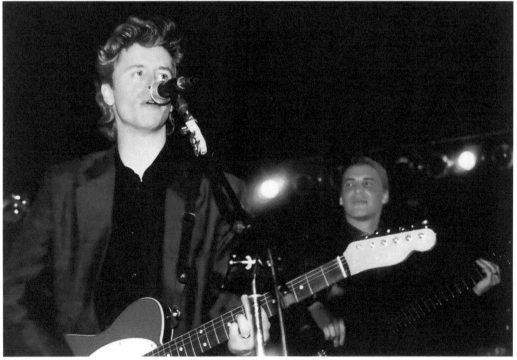

ALBERT COLLINS

October 3, 1937–November 25, 1993

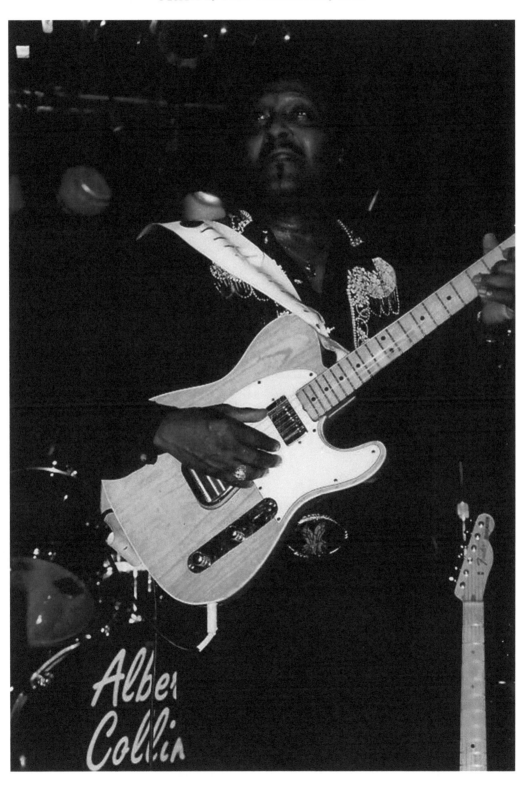

GRAPHIC MOVES

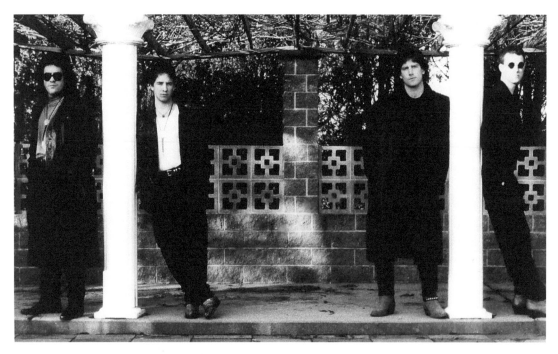

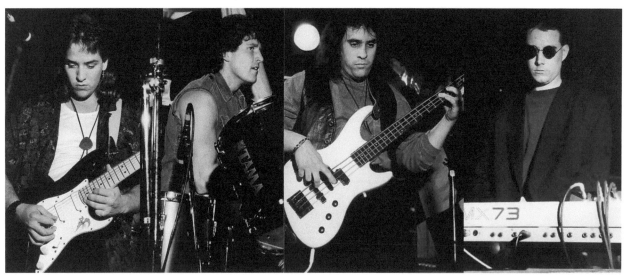

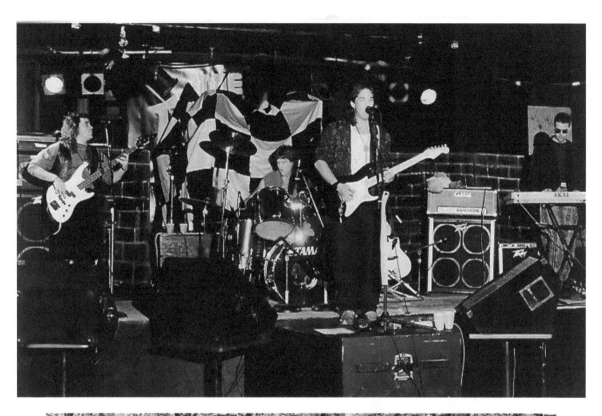

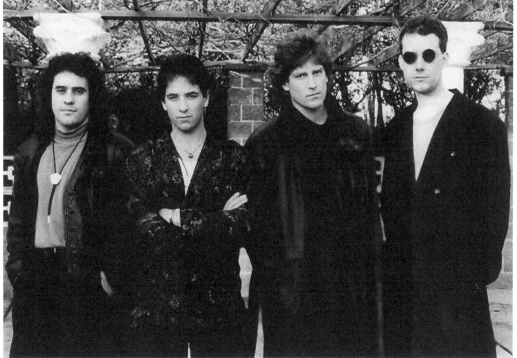

MUSICIANS AND ME

Stevie Ray Vaughan

Joe Lynn Turner from Deep Purple

Extreme

Jon Butcher

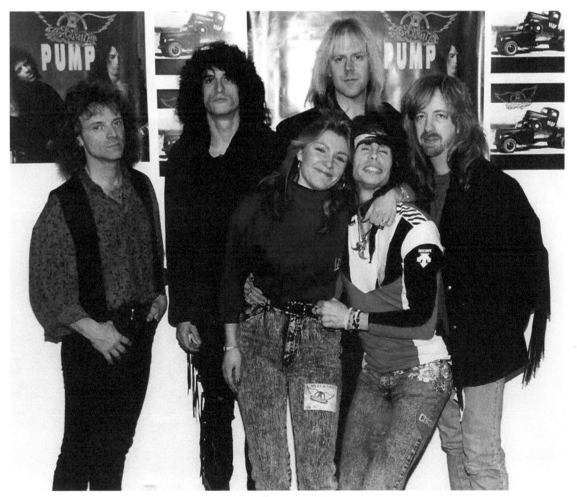

Aerosmith

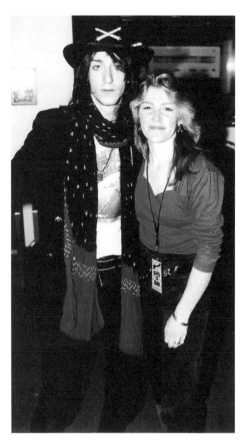

Chris Robinson from The Black Crowes

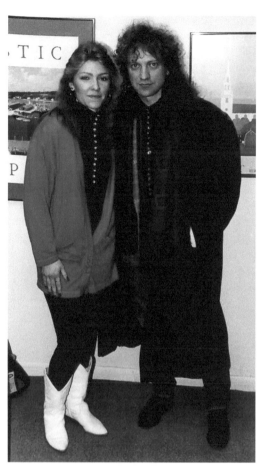

Lou Gramm from Foreigner

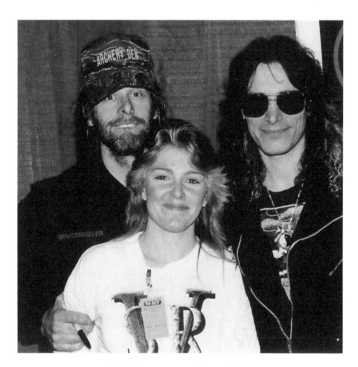

Ted Nugent and Steve Vai

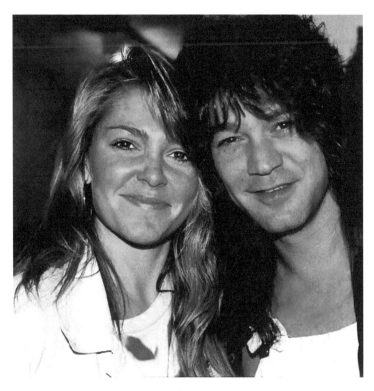

Eddie Van Halen

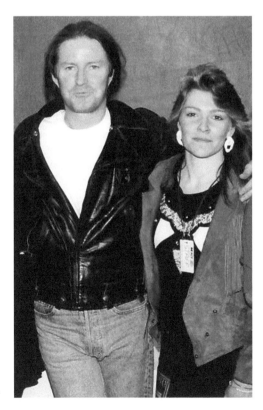

Don Henley

The Nelsons

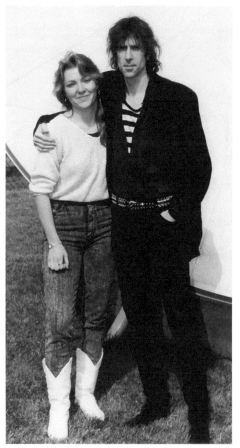

Peter Wolf

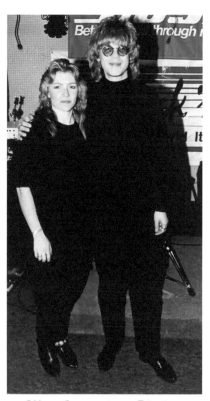

Elliot Easton from The Cars

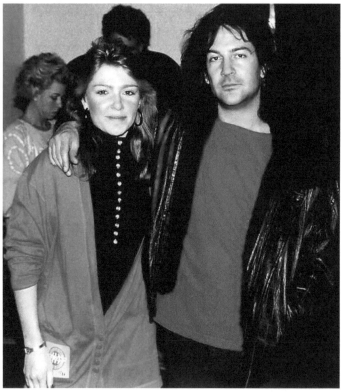

Billy Squier

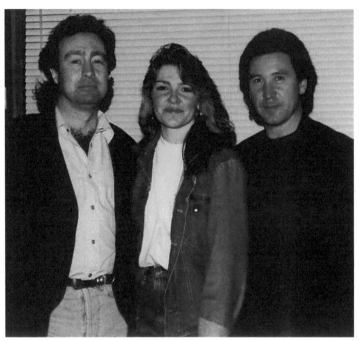

Paul Rodgers and Kenney Jones from The Law

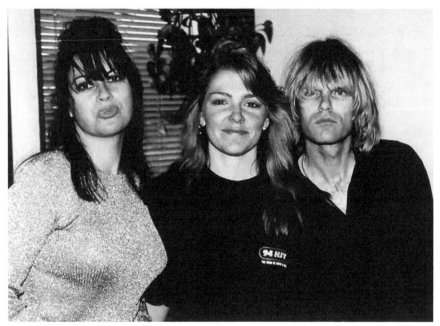

Christina Amphlett and Mark McEntee from The DiVinyls

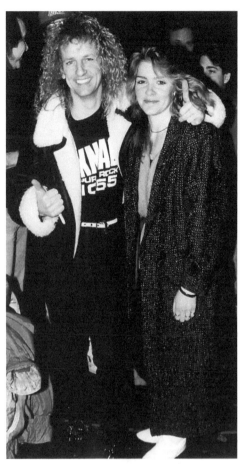

KK Downing from Judas Priest

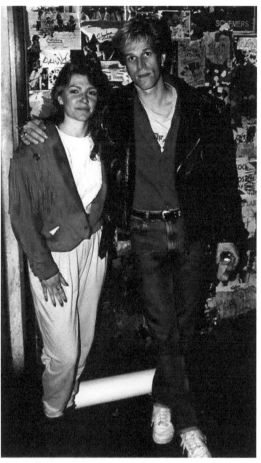

Stewart Copeland from The Police

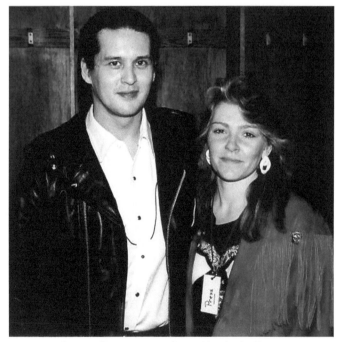

Frank Simms from Don Henley's Band

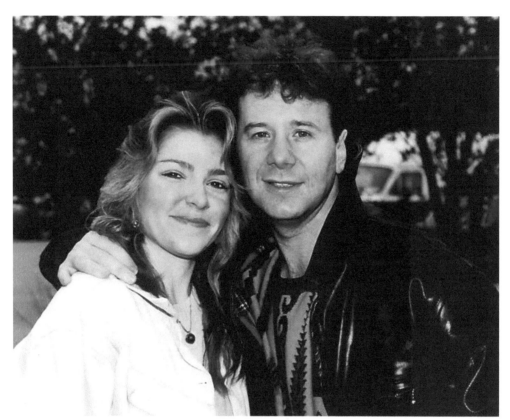

Jim Kerr from Simple Minds

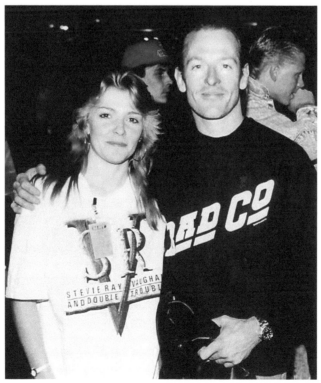

Simon Kirke from Bad Company

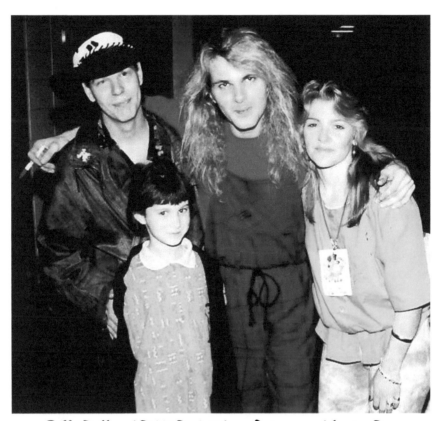

Bobby Dall and Rikki Rockett from Poison, and Jessica Rees

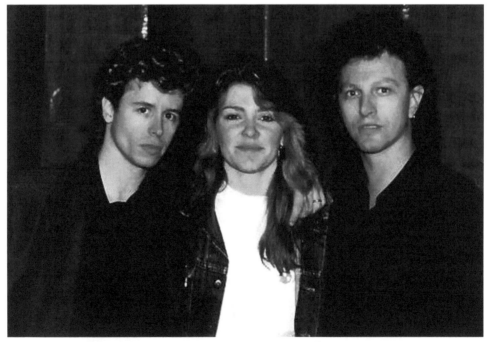

Phil Solem and Graham Edwards from The Rembrandts

WHJY Studio, Remote and Radio Interviews

Joan Jett

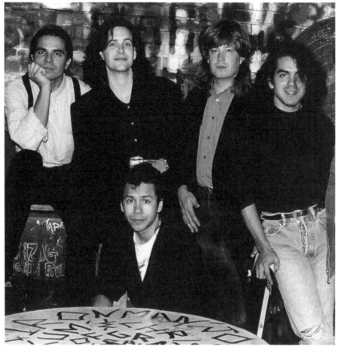

The BoDeans

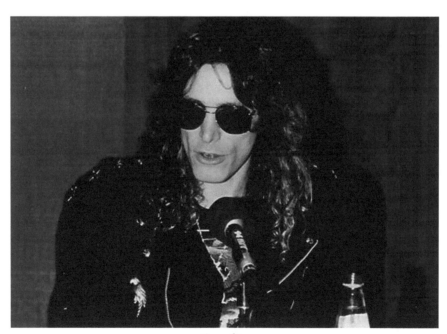

Steve Vai

Vince Neil

John Hiatt

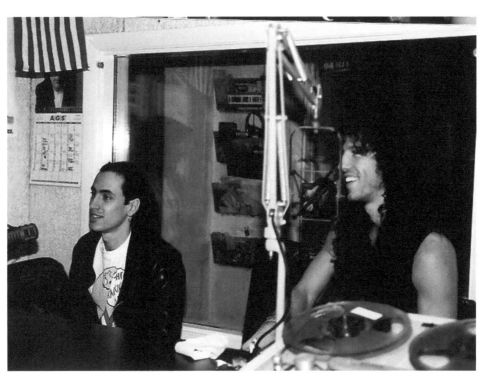

Nuno Bettencourt and Gary Cerone from Extreme

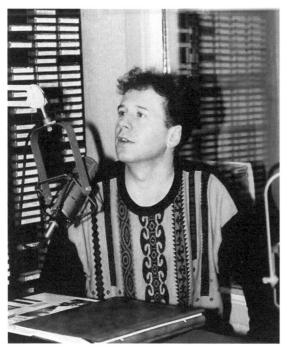

Jim Kerr from Simple Minds

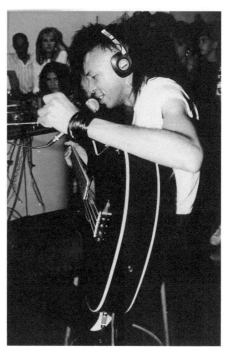

Doug Pinnick from King's X

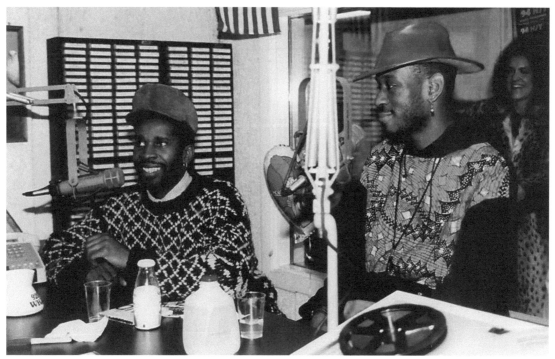

Cory Glover and Vernon Reid from Living Colour

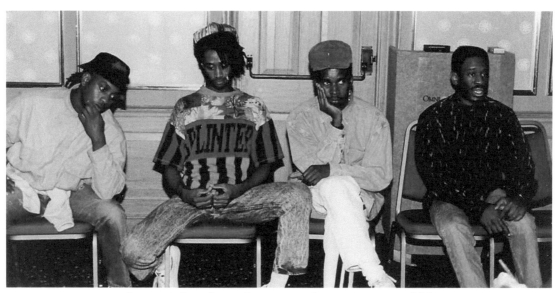

Living Colour Press Conference, Providence, RI, 1989
Corey Glover, Muzz Skillings, Vernon Reid, and Will Calhoun

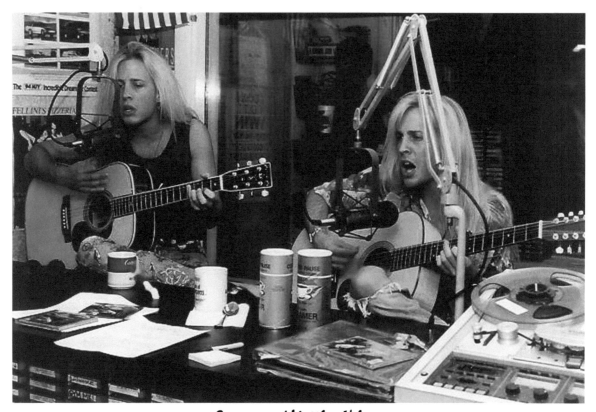

Gunnar and Matthew Nelson

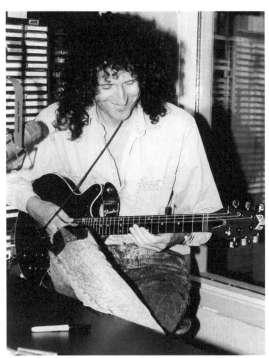

Brian May from Queen

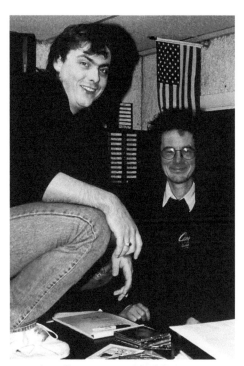

Lou Brutus and Noel Redding

WHJY DJ LOU BRUTUS DOING INTERVIEWS WITH...

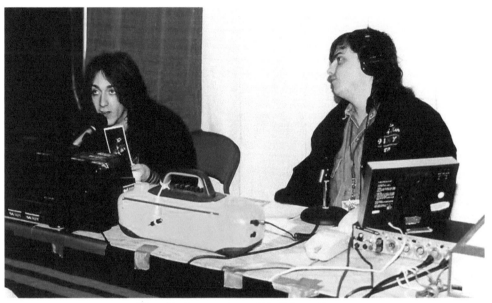

Chris Robinson from The Black Crowes

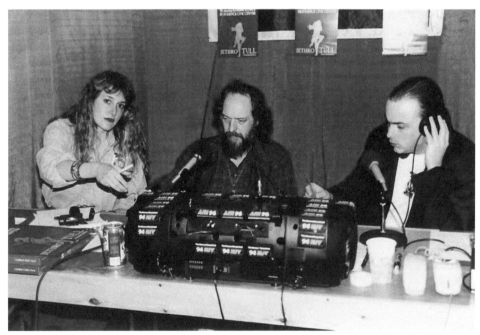

Ian Anderson from Jethro Tull

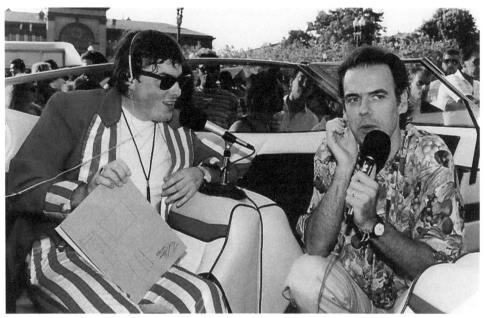

John Hiatt

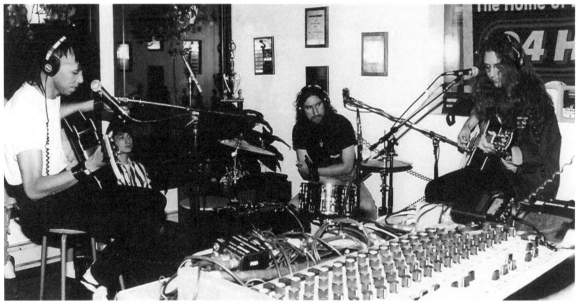

King's X

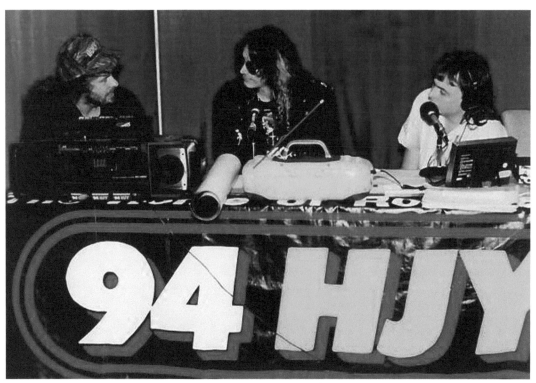

Ted Nugent and Steve Vai

Musicians with WHJY Personnel

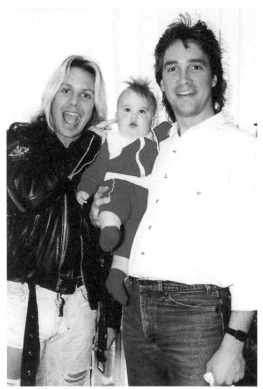

Vince Neil with Paul and Bill Weston

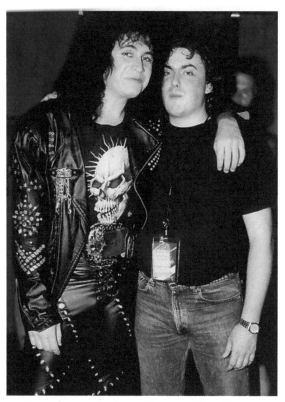

Gene Simmons from Kiss and Lou Brutus

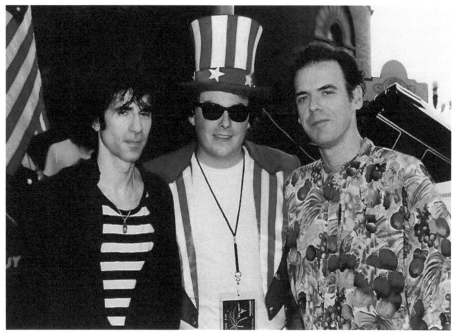

Peter Wolf, Lou Brutus and John Hiatt

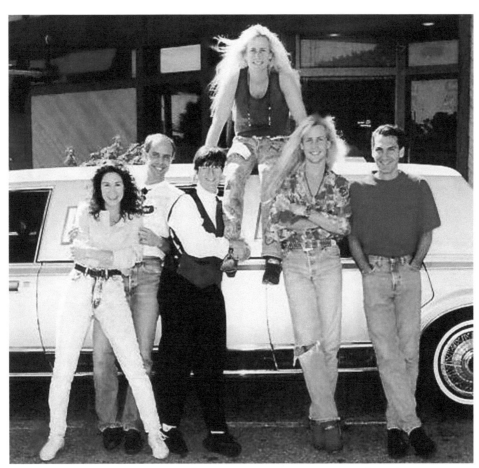

The Nelson's with Sharon Schifino, Chris Hermann and Phil Marlowe

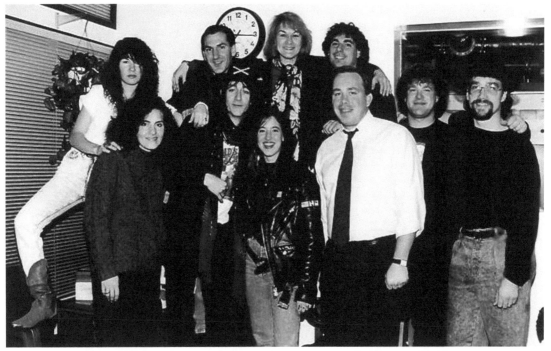

Chris Robinson from the Black Crowes and the WHJY On-Air Team

Grace Slick from Jefferson Airplane and DJ Rick O'Brien

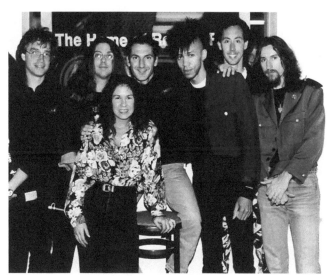

King's X with the WHJY On-Air Team

Human Radio with Lou Brutus
Photograph appeared in Billboard Magazine 11/10/90

Vince Neil and Lou Brutus

Aerosmith with James Evans, Chris Hermann, Lou Brutus, Bill Weston and Beth Holland

Extreme with Lou Brutus, Chris Hermann, Sharon Schifino and Phil Marlowe

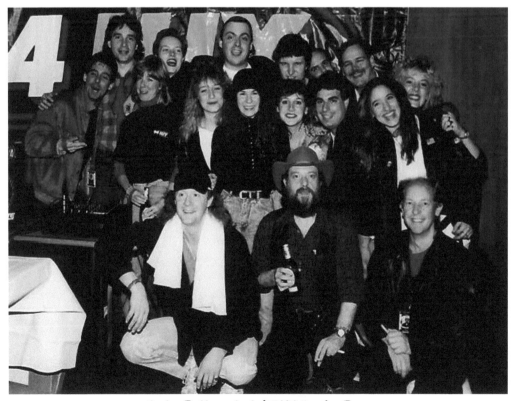

Jethro Tull with the WHJY On-Air Team

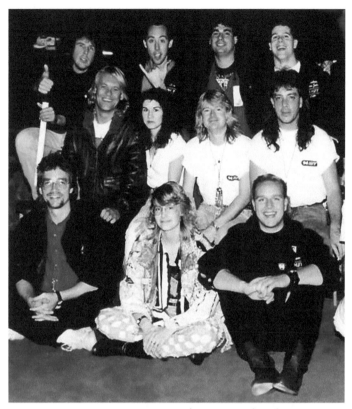

Bad Company with the WHJY On-Air Staff

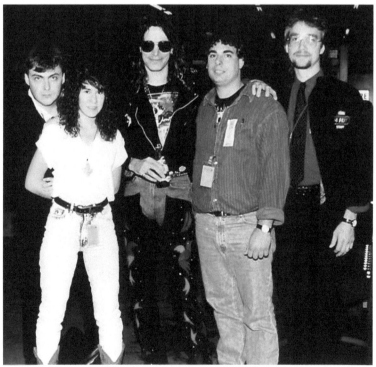

Steve Vai with Lou Brutus, Sharon Schifino, Dennis O'Heron and Bill Weston

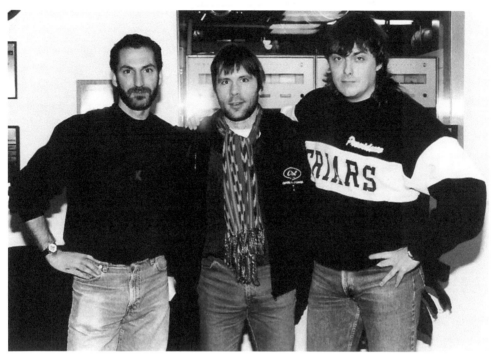

Phil Marlowe, Bruce Dickinson from Iron Maiden, and Lou Brutus

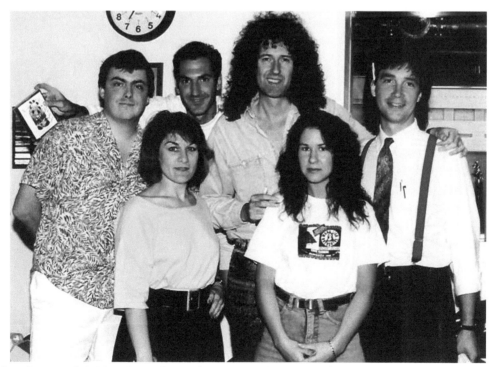

Lou Brutus, Phil Marlowe, Brian May from Queen, Bill Weston, and Sharon Schifino

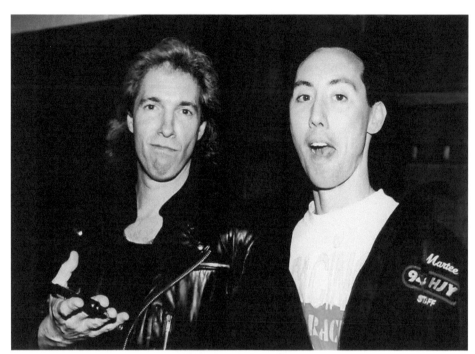

Francis Buchholz from The Scorpions and Martee

Phil Solem and Graham Edwards from The Rembrandts with Dennis O'Heron

In Loving Memory of
Michael "Dr. Metal" Gonsalves
September 17, 1962–February 20, 2003
Victim of The Station fire

"Dr. Metal", Sharon Schifino and Beth Holland

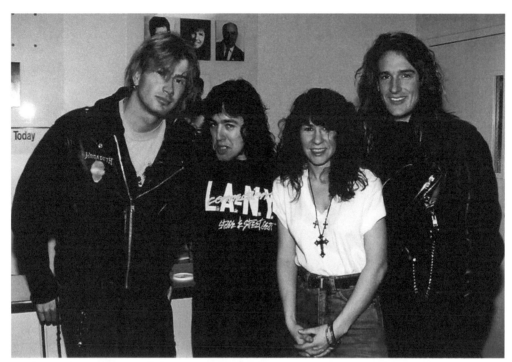

"Dr. Metal" and Sharon Schifino with Dave Mustaine and David Ellefson from Megadeth

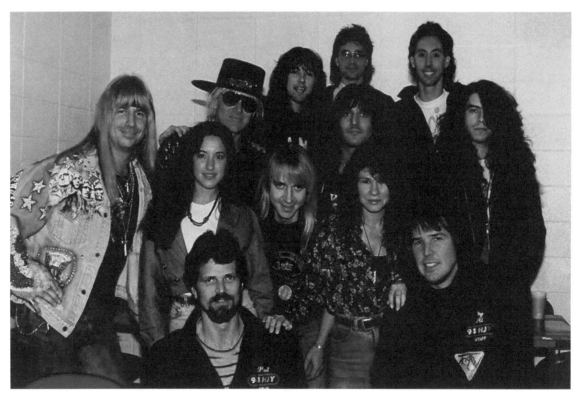

Jack Russell, Mark Kendall, Audie Desbrow, Tony Montana and Michael Lardie from Great White with "Dr. Metal", Bill Weston, Martee, Julie, Sharon Schifino and Paul & Al from WHJY

Jon Butcher with my parents, Dean and Judi Jennings

Jamie Carter from Jon Butcher Axis and Jessica Rees

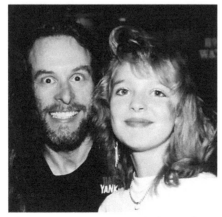

Ted Nugent and my sister, Rebekah Jennings

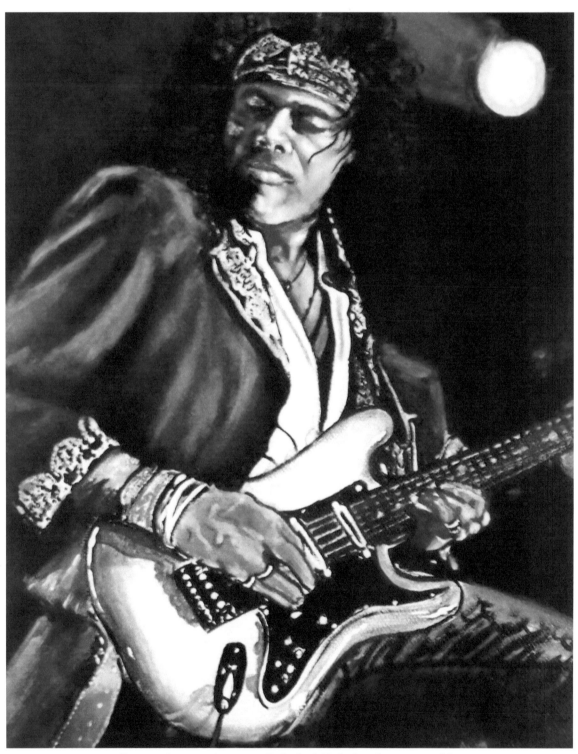

Original artwork copyright Judith Haladay Jennings 1992

Victoria Mitchell is a wife, mother, writer, agent, professional photographer, nondenominational Pastor, spiritual energy healer and an unschooler. She lives with her husband, Robert, who is also a Pastor and their three children, Ariel, Jeremy and Autumn, in beautiful Sebastian, Florida. She also has two stepchildren, Jamarr and Monique. Victoria loves being out in the Florida sunshine with her family and friends, and helping others as much as she can. Her family enjoys an active spiritual life and they plan on building a spiritual center to serve many in the coming years.

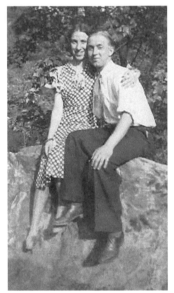

Mary Catherine (LeBlanc) and
Henry Haladay, 1934

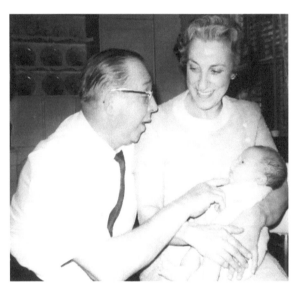

My grandparents and me in 1966

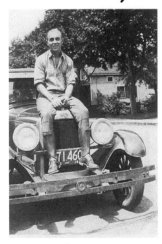

Grampy

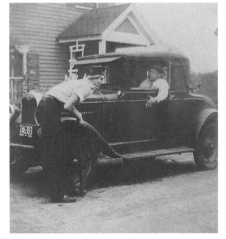

Henry and Fred Haladay
Wakefield, MA

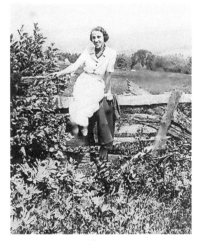

Nana

FINI

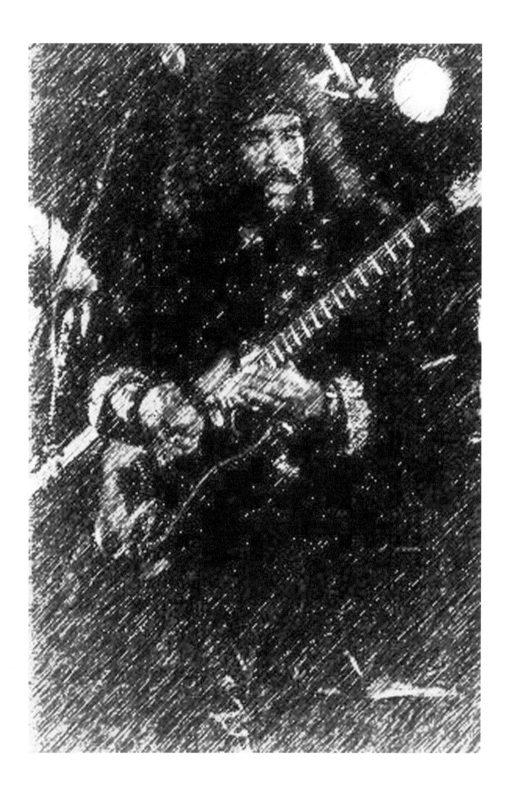

Printed in the USA
CPSIA information can be obtained
at www.ICGtesting.com
LVHW062157231123
764531LV00046B/9